VODOU

THINGS

Folk Art and Artists Series
Michael Owen Jones
General Editor

Books in this series focus
on the work of informally
trained or self-taught artists
rooted in regional, occupa-
tional, ethnic, racial, or
gender-specific traditions.
Authors explore the influ-
ence of artists' experiences
and aesthetic values upon
the art they create, the pro-
cess of creation, and the cul-
tural traditions that served
as inspiration or personal re-
source. The wide range of
art forms featured in this se-
ries reveals the importance
of aesthetic expression in
our daily lives and gives strik-
ing testimony to the richness
and vitality of art and tradi-
tion in the modern world.

VODOU THINGS

The Art of Pierrot Barra and Marie Cassaise

Donald J. Cosentino

University Press of Mississippi Jackson

Photo credits: Doran Ross, plate 1; Fowler Museum, plates 5, 8, 13, 14, 16, and p. 18 (left); Selden Rodman Gallery, plate 17; Marc PoKempner, from the collection of Nancy Mickelsons, plates 24, 25; Marilyn Houlberg, p. 16 (top right and bottom); Edizioni Cantagalli, p. 18 (bottom); UCLA Wight Gallery, p. 30 (left); Stux Gallery, p. 30 (right); Susan Einstein, Fowler Museum, p. 33 (top); Barra collection, pp. 38 (bottom); *Vanity Fair*, p. 41; James Bassler, from the collection of M. O. Jones, p. 43; all other photos by the author.

01 00 99 98 4 3 2 1

The paper in this book meets the guidelines for permanence and durability of the Committee on Production Guidelines for Book Longevity of the Council on Library Resources

Library of Congress Cataloging-in-Publication Data
Cosentino, Donald, 1941-
 Vodou things: the art of Pierrot Barra and Marie Cassaise / Donald J. Cosentino.
 p. cm. — (Folk art and artists series)
 Includes bibliographical references.
 ISBN 1-57806-014-1 (alk. paper)
 1. Barra, Pierrot — Criticism and interpretation. 2. Cassaise, Marie — Criticism and interpretation. 3. Outsider art — Haiti. 4. Voodooism in art. 5. Art, West Africa — Influence. I. Title. II. Series.
 N6608.B274C67 1998
 709' .2 — dc21
British Library Cataloging-in-Publication data available

CONTENTS

Pierrot Barra and Marie Cassaise are the most arresting artists I have found in more than ten years of researching Vodou in Haiti. Their powerful and mysterious sculptures are unique expressions of the Vodou aesthetic. Their work defines a tradition of African-American art already hundreds of years old, and pushes that tradition in directions which would be called postmodern in other cultures. Pierrot and Marie are profoundly Haitian, and profoundly folk, yet their art resonates with the work of a cosmopolitan array of artists whom they will never directly know. There are influences from Kongo and Dahomey in their art, and images from pop Catholicism, but evidence of Planet Hollywood and Madison Avenue is also to be found among the bewildering recyclia available in downtown Port-au-Prince, where they live, work, and sell their art to other Vodou priests and to hip collectors from SoHo to Cologne.

Mesi ampil to Pierrot and Marie for allowing me to sit in their atelier and for trusting me with their stories. *Mesi anko* to Georges René, Legba incarnate, who has lifted many barriers for those who seek Vodou, and to Gladys Maitre, who has given her friendship and counsel freely at Chez Michou, Reine de Saut d'Eau, and at all sorts of temples in between.

In Haiti, artists and priests must draw inspiration from the communities which sustain them. So, too, must researchers.

For the last twenty years I have been inspired by the effervescence, street savvy and unerring eye of Marilyn Houlberg, who introduced me to the work of Pierrot Barra and then encouraged his development, as well as my own. Special thanks also go to Doran Ross, director of the Fowler Museum and of the exhibit *Sacred Arts of Haitian Vodou*, which Marilyn and I cocurated. Doran's immediate enthusiasm for Barra's art insured it a prominent place in the exhibition and catalogue, and gave it entree into an international arena.

The Fowler Museum has made an important collection of Barra's sculptures, and generously allowed the reproduction of several studio photos in this book. Marianne Lehman has likewise been generous in letting me photograph early Barra pieces from her amazing collection of Vodou art administered by *La Fondation pour la préservation, la valorisation et la production d'oeuvres culturelles haitiennes.*

I am grateful to Mike Jones for hounding me into finishing this text, and to JoAnne Prichard at the University Press of Mississippi for her helpful doubts. *Mille grazie* to the Rockefeller Foundation for inviting me to be a resident fellow at the Villa Serbelloni in Bellagio, Italy, where for one month I worked on this text in an office built over a sixteenth-century shrine to Our Lady of Monserrato. Conjuring Vodou on Lake Como, under the gaze of a Black Madonna, was very heaven.

PREFACE

5

Working with the Barras has been intense, but it has also been fun. The joy comes from sharing a passion for their art with wonderful friends and colleagues. In this category I wish to acknowledge David Mayo, the brilliant designer of the *Sacred Arts* exhibition, whose personal aesthetic also runs to reassembling a Barbie doll or two. Randall Morris, Christianne Bourbon and Renald Lally have proved to be far-sighted patrons and collectors of the amuletic arts of Haiti. In the dead of a Chicago winter Nancy Mikelsons providentially found and had photographed two sculptures which confirmed the persistence of Barra's visionary eye. Finally, I remember with a special nostalgia the words of Virgil Young, a most passionate and rigorous aesthete of Vodou arts, who discovered the work of Pierrot Barra near the end of his life. Looking at one of Barra's sculptures intensely for several moments, from this angle and that, Virgil paused, looked at me, and said, "Now *that's* an artist."

As always, apart and in a special category, I acknowledge the women in my life, Henrietta, Julia and Delia, who have made loving the work of Pierrot Barra and Marie Cassaise a family affair.

A Walk Downtown

Ayé l'ọjà; ọrun nilé. The world is a market; heaven is home.
> *Yoruba proverb*

A heap of rubble, piled up at random, is the fairest universe.
> *Heraclitus*

To find Pierrot Barra and Marie Cassaise, you must elbow and shove your way into the Iron Market. These artists keep their shop deep inside this century-old market-place, an infernal warren of stalls and ateliers covered by a wrought iron shed all tarted up with faux minarets and turrets, like a Disney version of the *Arabian Nights*. Similarities with *Fantasia* end there however, since this castle of Haitian commerce is located in the mud, filth and choking exhaust of downtown Port-au-Prince, a ramshackle city once described by a disgruntled visitor as the "Paris of the gutter." Depending on your sensitivity to heat, light, touch, noise and smell—on whether these sensations, pushed to an extreme, excite or frighten you—a descent into the Iron Market is a trip to heaven or to hell.

A couple of streets east of the Iron Market is the city's Catholic cathedral, newly painted pink and cream, with clam-shaped towers which the irreverent laughingly call the twin vaginas. At a towering concrete crucifix, planted between the church and the street, women with upraised arms pray indiscriminately to "Jezy"

(Jesus) or to "Bawon" (Baron Samedi), the Vodou god of death and sexuality. For many Haitians, Jesus and the Baron are the same divine person sharing the same cross. At a crossroads near the market, the junction of streets is similarly designated as Croix des Bossales—Cross of the Unbaptized. During colonial days the bodies of slaves who died before being baptized were tossed there into a common grave. The unsettled outrage of their fate marks Croix des Bossales as a *pwen*, or point of energy, from which angry spirits of the unjustly killed seep into the daily life of the city.

You may hear the rage of the *bossales* in the snarled, honking traffic around the market, or smell it in the mud and mountains of garbage rotting inches away from the cool blue vitrines of the Syrian shops, where Versace socks and chrome-bladed Sanyo fans remind you how cosmopolitan—and hopelessly unequal—Port-au-Prince is, and has always been. Push through the cars and trucks, past the women selling rice and beans from huge iron pots, past money changers waving bundles of fetid gourdes, past vendors of used American "Kennedy" clothes, electric circuit boards, car parts, pink dolls in plastic-wrapped Mattel boxes, walls of Catholic holy pictures, trays of Pante condoms and cartons of Marlboros, and into the covered shade of the tourist section of the Iron Market.

7

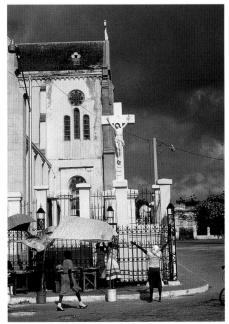

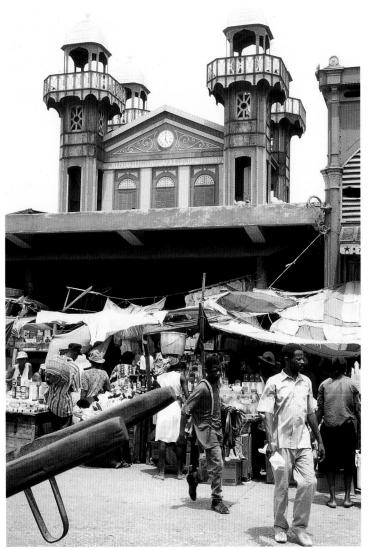

Left:
The Iron Market in downtown Port-au-Prince.

Above:
Crucifix raised near the Port-au-Prince cathedral, where Vodouists pray indiscriminately to Jesus or to Baron Samedi.

8

By now a half-dozen unsolicited touts are pulling you in opposite directions, through piles of straw hats and salad forks painted with tropical fruits, into less predictable displays of cloth dolls, sequined bottles and beaded calabashes—ritual objects of Vodou worship which at one time attracted some tourists, back when there were tourists in Haiti. Rumors of AIDS, ten years of political violence, and a hugely popular American invasion have reduced the foreign population to a motley crew of development hustlers, UN cops, writers and journalists on odd assignment, and a handful of those truly jaded world travellers always anxious to touch bottom—with rum glass in hand.

Piles of used magazines are sold just beyond the unbought tourist art. With their photos of faded heroes and last year's fashion ads beckoning from torn pages, these old magazines carry mysterious messages from unknown emporia which have fed the Haitian imagination for centuries. Just past these purveyors of yesterday's news, the Barras maintain their stall. There Pierrot might be found fixing a Christmas wreath to one of his altar installations or Marie Cassaise hawking some fabulous concoction of dolls and spangles that looks like nothing you've ever seen before (plate 1).

Somehow they've managed to fix into their wares all the bustle of the market you've just transversed. They have swept up its glitter, its hurry, its ersatz luxury: rubber dolls, sunglasses, holy cards, salad forks, sequins, bones, speedometers, rosaries, earrings, mirrors, ornaments, tinsel, velour. They've torn it apart, put it back together with pins, and wrapped it up in cellophane, in the process transforming heaps of random junk into works of sacred art. Although William Butler Yeats could not have imagined their work, he managed to describe the mystery of its creation well enough: "All changed, changed utterly: / A terrible beauty is born."

Designing Dreams

Through Vodou we are dreaming with an open eye. Anything can be a reason to dream.
Bobby Denis (from an interview on *Afropop International*, National Public Radio, 1993)

I had known Pierrot Barra and Marie Cassaise for three years before I asked them about their lives. Marilyn Houlberg, fellow devotee of Afro-Atlantic ecstatic arts and intense admirer of the Barras, had directed me to their stall in 1991. There I found Pierrot working on an altar installation for Ezili Dantò, mother goddess of the Vodou pantheon (plate 2). Her head was a plaster doll's, rouged, lipsticked and crowned with a puff of white synthetic hair. She was holding a cutout holy picture of the baby Jesus, perceived by Vodouists not as the Son of God but as Anais, daughter of the hardworking, hard-living goddess Dantò.

9

Wrapped around the body of the goddess was a red fabric snake, with another doll's head. A third doll, a little rubber baby, was nestled at the foot of the statue. The piece was seamless, the snake enfolding the figures encrusted with sparkles and dimestore jewelry, the ensemble dominated by majestic Dantò.

Barra's sculpture resembled no object I had ever seen in any *ounfò* (Vodou temple). But it did share with most Vodou art a common source in Roman Catholic imagery. All the major *lwa* (Vodou divinities) are recognized in the iconography of the Catholic saints, especially the massproduced chromolithographs whose glossy images *signify* (in the African-American sense of the word) correspondences between saints and lwa. In this case, Barra's sculpture was playing off the chromolithograph of the Black Madonna (*Mater Salvatoris*), who *is* Ezili Dantò. He cut her daughter, Anais, out of a standard chromolithograph, and then riffed off Dantò's divine affinities with the snake deity, Danbala, and with Marasa, the sacred twins, to create this ensemble. Barra expresses the composite nature of Vodou divinity through the layering of media. Dantò is plaster and plastic, synthetic fiber and holy pictures, rouge and spangles and calabashes. In spirit and substance—materially, historically and theologically—she is an assemblage, a form composed from separate elements of the same or mixed media. Assemblage is Pier-

rot Barra's style. It is also the principle aesthetic of an Afro-Atlantic culture which profoundly influences all the sacred arts of Vodou (Blier 1995: 60–87).

I was not prepared to make such sweeping judgments at that time. But I bought the Dantò sculpture, had her wrapped in heavy plastic, and crossed the street to Chez Michou, the shop of my friend and mentor Gladys, shrewd businesswoman and *manbo* (priestess) extraordinaire. As was often the case, Gladys was entertaining several other manbos and *oungans* (priests) who were chatting around gigantic bags of the various dubious substances Gladys sold. When I unwrapped Barra's creation they stopped talking to stare. Then Gladys started singing a praise song to Ezili Dantò which was quickly picked up by the others. I asked if anyone recognized the artist, but no one did. Nor had anyone ever seen any piece like this in any ounfò. It was not traditional, they said, but it certainly was Vodou. It was powerful. It was very beautiful. And it was something new.

Other Vodouists have commended Barra's work in similar ways. A couple of years after the epiphany at Chez Michou, Mama Lola, a celebrated manbo from Brooklyn (Brown 1991), visited our home in L.A. Seeing Barra's sculpture on our mantel, she approached it and began singing a praise song to Ezili Dantò who is special patron of the hardworking, hard-

living Haitian women of New York. Soon after Lola's homage, I was back again in Haiti negotiating for the museum purchase of yet another Barra Dantò, a gigantic sculpture of the enthroned goddess fabricated from wood, satin, plastic, sequins, beads, pins, ribbon and lace. After the sale, this Ezili was hoisted onto the back of a flatbed truck and driven from the Iron Market to the Holiday Inn where Barra's holdings were being consolidated. In her progress through the streets, the enthroned goddess managed to turn heads, stop traffic, and draw admiring throngs to her temporary station in front of the hotel casino (plate 3). These blasé Haitians, familiar with old images of the lwa, were saluting something fine and new.

I have returned many times to visit the Barras, first as an admirer of their art, and then as curator of a travelling exhibition which would highlight their work. Pierrot understood and approved of my research. He brought me to his home, an enormous half-made hulk in the town of Croix-des-Missions, and showed me the huge altars he was constructing for his patron lwa; everything in the dark basement rooms appeared outsized, intimidating, and unfinished. On a more personal level, he trusted me with a packet of family photographs which he hoped I would include in this book. Then, in November 1994, he and Marie consented to a video interview which took place in front of a downtown

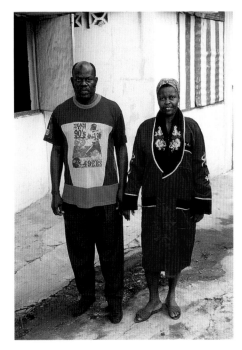

Marie Cassaise wears a dragon robe.

warehouse, where various of their sculptures were being packed for shipment to the museum. Before I started the camcorder, Pierrot brought out a navy blue gown decorated with golden Chinese dragons which he helped Marie put on. That gesture marked the affection in their relationship, as did his request that I include her in whatever I wrote about them.

In the course of the interview, Pierrot was often interrupted and corrected by Marie, or by Georges and Michel, a couple of tagalong "fixers" anxious to amplify their gnomic responses. A fixer is a professional culture broker whose range of activities

11

runs from valet to research associate. In Haiti, where telephones often don't work, and where every transaction entails complicated personal and financial negotiations, fixers are essential to the conduct of any serious business. But their interventions also introduce more static into already fuzzy communications. Between the cacophony of voices, pounding of hammers, and stare of the camera, there was no shortage of such static. Most of the information that did filter through my questions and Barra's answers was therefore provisional. In the course of other encounters, different stories would be told. Life histories were never complete. Such a clouded state of knowing is not at all unusual in Haiti, where the facts of a life—like the objects on a Vodou altar—are always open to rearrangement.

This much of the story I learned from that interview. Pierrot Barra was born in 1942 in Bel Air—a district of Port-au-Prince which, despite its salubrious name, is a warren of old houses set on a low hill above the pestilential fumes of the Iron Market and the roil of Croix des Bossales. His mother was a manbo and a flag maker, with a stall in the Iron Market. He assisted her for thirty years, but for the last seven he's been making "Vodou Things." (In later discussions I learned that Barra's time references were mostly poetic, indicating periods of duration rather than calendar dates. In a similar fashion, Vodouists say

there are 401 or 1601 deities, though no one has actually counted them. In Haiti numbers are metaphors as well as ciphers.) Although Pierrot will still make flags on commission, he has no further interest in that kind of work. The spirits want him to make only Vodou Things, his term for genres of sculpture which he alone creates.

Pierrot and Marie Cassaise married in 1971, and have been collaborators ever since. Both are initiated into the Vodou priesthood. Marie Cassaise is a manbo. Pierrot was initiated as an oungan when he was thirteen. He is also president of a Bizango group, the most secret of Haitian societies, which has a sinister reputation for social enforcement, including the creation and maintenance of zombies, those soulless vagabonds of Haitian (and Hollywood) folklore. Belief in the "differently dead" (as one satirist recently dubbed zombies) is widespread in Haiti, and is understood by ethnobotanist Wade Davis (1986) to constitute Bizango's unique form of capital punishment. Barra justifies his membership in such an intimidating organization by explaining that "it doesn't mean that I am a criminal, evil, or kill people. I need an arm to protect me. You have a good side, but you need a bad side when people challenge you, or hate you. So I am a member of Bizango."

Bizango symbols are manifested everywhere in Barra's work. Crucifixes, skulls and coffins suggest the dread powers of

the society and its ancient links with Freemasonry, whose regalia and rituals have been extensively borrowed by Vodou priests and artists (many of whom are also Masonic initiates). Baron Samedi, Iwa of death and 33rd Degree Initiated Mason, is the dark spiritual link between these groups. The Baron is manifest in each crucifix Barra fabricates. But he is hardly the only Bizango spirit so evoked. Barra has created an extremely florid coffin (*sekey madule*) for the mummy in sunglasses he identifies as the Bizango queen (plate 4). "When the Bizango band comes out, the coffin is in front. She leads the way. Two persons hold the coffin and balance it. Then they march, all the people behind in the band. They can change things because she is magic. She owns all the magic. She controls all the people in the group. All the power of magic is from her. That's what the coffin symbolizes: to her belong all things."

Bizango spirits are a subset of the Iwa whose centrality to Vodou is apparent in every piece of art Barra has ever made. Through a complex spiritual chain of being, Iwa (or "the Mysteries") link mortals to an unknowable creator (*Bon Dye*, the "Good God"), who is vaguely associated with the Christian deity. Acting in many ways like supersaints or angels, the Iwa personify aspects of human nature (love, strength, anger, wit, passion, endurance) or natural and cultural phenomena (the forest, the

sea, agriculture, fire, the oceans, war, death, sexuality). Like the living community with whom they constantly interact, the Iwa are divided into "nations." The most important of these divisions are Rada and Petwo.

Rada Iwa descend from the old gods of Dahomey in West Africa, and have made an easy synthesis with the iconography of the Catholic saints. Prominent among the Rada Iwa are Danbala and Ayida Wedo, the ancient snake-creators of the earth; Agwe, admiral of the seas; Zaka, patron of farmers; and Ezili Freda, goddess of love. They are often described as "cool" or "family" spirits. In contrast, the Petwo nation is hot, red, powerful, quick and angry. They are not family intimates, but may be contracted to serve as powerful patrons and allies— for a price. The divine ancestry of Petwo is mixed, with clear roots in the Central African culture of Kongo as well as in African New World experience. Prominent among the Petwo Iwa are the Earth Mother, Ezili Dantò, and her family of angry, red-eyed sisters and cousins; Gran Bwa (Big Tree), the spirit of the forest and its healing leaves; and Bosou Twa Kon (the Three-Horned Bull), who serves as the Petwo muscleman.

Divisions between Petwo and Rada are by no means definitive or absolute. Certain Iwa, like St. Jacques and his family of brother military spirits (the Ogous), or the ghoulish family of Baron Samedi and

their trickster children (the Gedes), slide easily between categorical divisions. Most ounfò have altars raised to the lwa of both nations, for in every life there is a time to be cool and a time to be hot.

"You may know the lwa through observing their horses," Vodouists say. And so it is that in the heat of a Vodou ceremony, the lwa "mount" (possess) their "horses," and through the agency of their borrowed human bodies make known their own peculiar and often capricious tastes, needs and wants. As a Vodouist climbs the various rungs of initiation, access to the lwa becomes easier. To the greatest adepts the lwa reveal themselves in dreams or in reveries known as *prise des yeux* (seizure of the eyes). The lwa who guide one's life (*met tet*, "master of the head") are seated just in back of the eyes, and so are immediately available to those with the power to call them forth.

St. Jacques Majeur is Pierrot Barra's met tet. He is "escorted" by Ezili Dantò (his consort in battle since the days of the Haitian Revolution); his military brother, Ogou Badagri; and Agwe, the admiral of the Vodou pantheon. Dantò and Ogou Feray (another brother of St. Jacques) are the met tet of Marie Cassaise. These lwa, mostly recruited from the hot and angry Petwo nation, are seated in the heads of the two artists, and serve in a very real sense as their daily muses. Their agency of communication is the dream. "When I

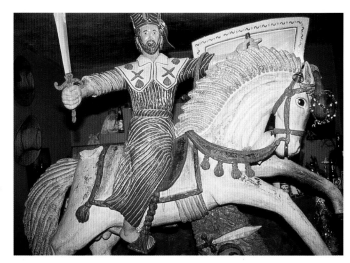

sleep, while I'm dreaming, I see the Mysteries," says Pierrot. "When I sleep I see the lwa, the spirits, the signs moving like this. When I sleep, when I dream, they show me a design . . . some face, some kind of thing. Then when I wake up, I create it." Marie says she does not dream these dreams, but sees them in her husband's work, and then she, too, gets involved.

Pierrot honors his met tet with a life-size equestrian statue of St. Jacques—a concrete casting copied directly from the chromolithograph—set in the middle of his basement altar. For this grand gesture the artist is daily rewarded. Once on St. Jacques's feast day, Barra dozed off. "While I was asleep I dreamt I saw St. Jacques as a physical person, and he said to me, 'I will give you work to do. If you're looking for material you will find it. I will show it to

Life-size statue of St. Jacques, Temple of Gesner, Port-au-Prince.

14

you.'" Pierrot says he derives all his material in this way. He never goes looking for anything. People bring things to him, or items suddenly turn up, brought by the invisible hand of St. Jacques. Even Pierrot's customers are mystically delivered. "When I have a dream and start to make a work, I know the person who will understand it. The spirit will *telephathize* [*sic*] the right person, who will understand it and come to buy it. Each of my pieces belongs to a very particular person."

On another occasion, Pierrot learned that my colleague was flying to Cap Haitien to attend the annual mud bath ceremonies for St. Jacques in the town of Plaine du Nord. Not wanting to be outdone, Pierrot sculpted an airplane for St. Jacques and his travelling companions, Ezili Freda and the Sacred Heart of Jesus ("a lwa who is pure and clean"). All their chromolithographs are set into the plane's windows (plate 5). Naturally, he painted St. Jacques's jet red and blue, Haiti's national colors, and pasted on cutout stars to signify the sky. When I queried him about this mystic airplane, Pierrot responded, "Let me help you to understand this logically. There is no spirit who can't go up into the air in his physical body. All the spirits in general are like the wind." Barra realized St. Jacques's aerial qualities again in a fiery-red wrapped sculpture of a rider mounted on what appears to be a horse springing from a carousel (plate 6).

The Valley of the Dolls

O you beautiful doll,
You great big beautiful doll,
Let me put my arms around you;
I could never live without you . . .
 Fred Fisher, 1911

Nothing is more startling in Barra's assemblages than his use of doll parts. He might indeed be described as the master of the refigured doll, an ironic epithet considering the role "Voodoo dolls" play in Euro-American stereotypes of black magic in Haiti and New Orleans. Vodou, which for a century has been associated with pins stuck in dolls, has traditionally made little use of them in its liturgical arts. In ten years of field work in the ounfòs of Haiti, I have yet to find a single doll stuck with a pin. Where one *does* often find cloth dolls (aside from those available in the tourist market) is in the cemetery. They may be positioned there near tombs, or, in one telling instance, bound to a tree with a rubber sandal. Such dolls are messengers and thus in need of sandals. They carry messages, often affixed to their bodies, from the living to the land of the dead.

Dolls may also be manipulated by manbos or oungans to effect magical transformations. Tied together or turned upside down, fêted or punished, dolls become human surrogates, agents of sympathetic or contagious magic. They play parallel transformative roles in those European and

15

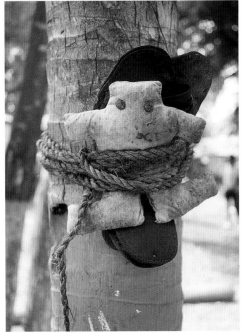

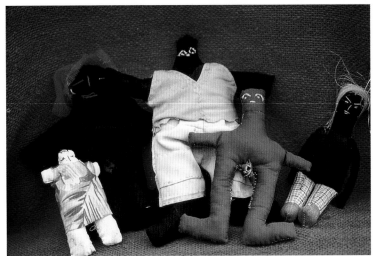

Above:
Messenger doll with a rubber sandal nailed to a tree in the Port-au-Prince cemetery.

Left, above:
Imported dolls are fetishized commodities in the Haitian market.

Left, below:
Dolls made for the "Voodoo" tourist market.

16

African cultures historically antecedent to Vodou. Mediterranean Catholics bury statues of St. Joseph (the model carpenter) upside down in their yards to insure the sale of homes. Blier (1995: 84) argues that the Fon *bocio*, a figurated object serving as a "conceptual corpse," is a probable African source for the cemetery doll in Vodou. In Kongo, the so-called "nail fetish," a figurated wooden "spirit-catcher" (*nkisi*) studded with nails, seems to present an obvious cognate to the so-called "Voodoo doll." But the nails stuck in an nkisi are empowering, not malignant. If the pinned doll ever did exist in Haiti (and there is no record of such) it was probably among the superstitious French colonists, not the Africans who drove them out.

Barra's dolls have nothing to do with any of these possible historic sources. They are assembled in foreign factories, and are thus enormously attractive in Haiti and other peripheries of the industrial world, where manufactured products are often fetishized. Barra claims that, as with his other materials, the lwa send him the doll parts. "I never move. I never go to buy them. They just bring the dolls to me. Always." A more cynical market tout insists that Pierrot and Marie have runners who rummage the trash dumps around the elite districts of Port-au-Prince for discarded toys, especially in the days following Christmas. If Barra's favorite media do indeed come from some valley of dumped dolls, then the ironies compound. His dolls pun not only the world market but conspicuous consumption by Haiti's notorious elites.

In his easiest refigurations, Barra simply gives the dolls a divine makeover. Thus a plaster *femme noire* from the tourist market is stuffed, padded and redressed in red headtie, florid gown and garish jewelry, *et voilà:* there is another daughter of Dantò, whom Pierrot calls "Manbo Zila" (plate 7). And when Dantò mounts her horse, Pierrot explained, she may take this doll he made and dance her around in the Petwo fashion. Or Dantò may set Zila on her lap in a chair, and thus reify the mater salvatoris chromolithograph. In more dramatic metamorphoses, doll bodies may disappear altogether. Sinuous coils fall from the rubber head of a doll transformed into a snake deity, Danbala or Ayida Wedo, or into the mysterious watery Simbi spirit which Vodou inherits from the Kongo (plate 8).

In the act of deconstruction rests the power of assemblage. A doll's head pulled from its body becomes something else. It acquires the terrifying qualities William Burroughs described in his cult novel *The Naked Lunch:* looking at the severed head is like staring at food on the end of a fork in the moment before it's eaten—the true alterity of the isolated part is suddenly revealed in all its nakedness. It becomes a *ding an sich,* to be treated with the same combination of horror and awe which the

17

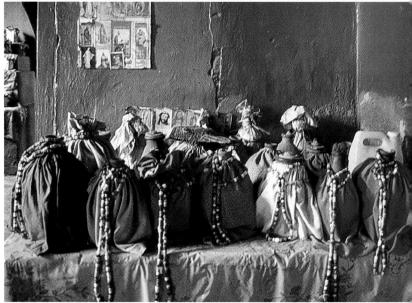

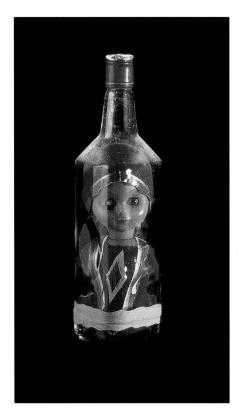

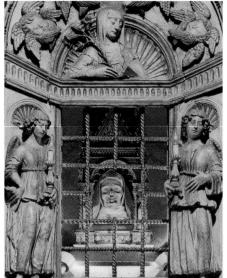

Above:
Wangas dressed for an altar.

Far left:
A doll set in a Vodou reliquary bottle.

Left:
The head of St. Catherine of Siena, set in a marble reliquary in the Basilica of S. Domenico, Siena, Italy.

church in patristic and medieval times afforded the detached body parts of a saint. Compare the head of St. Catherine of Siena, enshrined in her reliquary, to the doll torso set in a Vodou bottle. Both contain the debris of sanctity. Catherine in her niche and Barbie in her bottle compel us to meditate on the hidden sources of divine power irradiating the tangible world. Each forces us to acknowledge the real presence of the spirit in the basest of materials. And either, if used with appropriate incantations, can cancel the laws of physics.

In a yet more complex assemblage, Barra has tied a brown rubber doll into a chair with ribbons and beads (plate 9). This piece resonates from Haiti back to Dahomey, where, Blier tells us, chairs are sometimes considered "vodun" (sacred) since they may "seat" powerful priests or objects (1995: 63–64). In Haitian Vodou, transformative agents (*wanga*) may also be seated, since they, too, emanate a power which must be contained. After being tied down, wanga may then be "dressed up" in satins and laces, just as this doll has been luridly reclothed to resemble not only wanga but the dressed statues of saints on a Catholic altar. Those are legs, however, which grow out from her shoulders where mortals have arms—two additional legs and feet, stretched out as if she were being crucified. Thus Barra has further reconfigured his doll to mirror lithographs of Shiva or Laksmi, in whose many limbs Hindu worshippers recognize the polydexterity of their gods. Such lithographs are also available in Haiti, where the divine mermaid Lasirèn may be recognized in the portrait of an Indian snake charmer (Houlberg 1996: 34–35).

This brown rubber doll is "Ti Jean Dantò," brother of Ezili and a *djab* (devil), who revealed himself to Pierrot in a dream: "One foot after another until there were four feet and no hands. When he's going to get people, he puts out one foot, and if they try to stop him, he puts out another foot, and then another one. Sometimes he puts out five feet. I see the feet coming, the feet coming, the feet coming . . . I was astonished. After I awoke, I worked on my dream for about a month. It came out looking just the way you see it." But Barra also had more tangible inspirations. He said that spirits like Ti Jean come to his house for a ceremony he does once every three years. "Spirits looking just like that. Spirits with ten heads come over. Different kinds of heads, the heads of young people, two years old, two months old—but after fifteen minutes, you don't see them anymore. You just see ordinary people again."

Perhaps Barra's finest materialization of such multiheaded visitors is an assemblage which he calls "The Escort of Ezili" (plate 10). Most lwa travel in convoys, the associated spirits being called escorts. Like most priests, Barra is careful to place his lwa with their right escorts. He bundles to-

gether the various sisters of the Vodou goddess of love and luxury, as he names them: "Ezili Freda, Gran Ezili, Lasiren, Simbi Dlo, Saint Claire, Gran Silibo, and Petite Freda." Marilyn Houlberg has written of this sculpture, "Female spirits of love, all aspects of Ezili, are bound together in the sculpture in a non-hierarchical fashion. These Ezilis, dark and light, fan out like a hand of playing cards, with their messenger spirit [Petite Freda] tied around the neck of the largest doll. This work makes concrete the idea that many Ezilis can walk together on similar paths. The very question of how many Ezilis there are in the Vodou pantheon suddenly becomes irrelevant when one stands in front of this powerful work which beautifully contrasts the elegant, embellished textile of the 'swaddling' clothes with doll heads of varying expressions and textures. The aesthetic and anti-aesthetic creatively collide in this work. Barra has truly 'performed' his Ezilis" (Cosentino 1996b: 28).

In this piece, as in so much of Barra's work, there is a final kinetic element which won't allow for aesthetic closure. It is that foot with red-painted toenails which he has allowed to peek out provocatively from the bunting. With that foot, the artist acknowledges that his Ezilis have not been contained, that the sculpture is out of his control and ready to leap to life. When I asked him about it, Barra simply answered, "It is the foot of the mystery. It is a pwen."

In Vodou religious art, pwen is a concentrated locus of spiritual energy, often realized in the form of a star, which allows for the seeping of the sacred into the profane. The urban intersection of Croix des Bossales in downtown Port-au-Prince is a pwen; so, too, is the foot of this sculpture. Pwen are transfer points—like the *omphalos* in Greek mythology—where spiritual potentiality is packed tight and shot out. Through the doll's foot, Barra says, the whole piece becomes "mystique."

Genres: Altars, Reposwa, and Mojo Boards

You don't make art, you find it. You accept everything as its material.
Charles Simic

Form and Function Vodou is a low-budget religion. It recycles all the world that comes its way. The same doll that arrives on an airplane from Miami in a pretty Christmas wrapping may be sitting on an altar three hours later. To what category of sacred art does that doll belong? Is it *art trouvè*? Collage or assemblage? Is it sacred, or even art at all? Since the lwa are capricious in taste and expression, most of the objects dedicated to their service raise similar categorical questions. In Vodou, objects are chosen, assembled and dedicated to deities whose tastes are shaped as often by fashion as by tradition. Thus any object may be sacred if it pleases the lwa, and is

20

repositioned on an altar to summon, appease, contain or direct their divine energies. As Georges René succinctly described it, "Anything can do *mystique* if you believe in it. Anything. You look at the thing—at the tree—and you do some kind of prayer, and the prayer becomes reality. You have to fix it to become a mystic. Like this, it can't be mystic. You have to turn it into mystic. You baptize it. You make a ceremony. You put the food the lwa eats, and then the oungan baptizes it. After that you can work with it. It gets a soul. You can put it on an altar." While many Haitians engage in this spiritual recycling, it is the peculiar genius of Pierrot Barra to discern new places to put a soul.

Altars are the ideal form for all Vodou's sacred arts. They are palimpsests of Haiti's twisted history, made coherent through the eyes of synchronous gods. To look at an altar cluttered with customized whiskey bottles, satin pomanders, clay pots dressed in lace, plaster statues of the saints or the laughing Buddha, holy cards, political kitsch, Dresden clocks, bottles of Moët et Chandon, rosaries, crucifixes, Masonic insignia, eye-shadowed Kewpie dolls, atomizers of Anaïs-Anaïs, wooden phalli, goat skulls, Christmas tree ornaments, and Arawak celts is to gauge the achievement of slaves and freemen who have imagined a myth broad enough and fabricated a ritual complex enough to encompass all this disparate stuff.

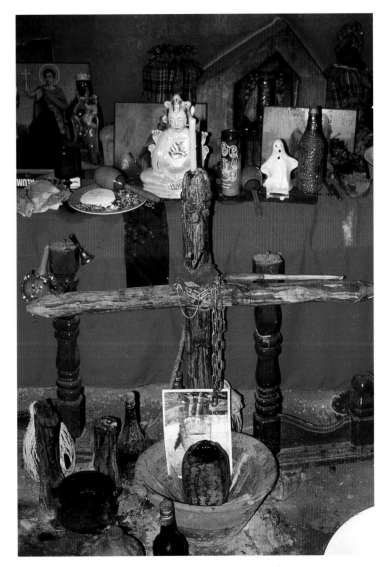

The Petwo altar of flag maker Clotaire Bazile, incorporating Casper the Friendly Ghost, a Chinese saint, the Black Madonna and St. Expedite.

2 1

Forced into the hellhole of colonial Haiti, African captives reassembled the objects they found there according to an aesthetic brought with them from Dahomey, Kongo and points in between. Out of thrown-away lace, sequins, feathers and empty whiskey bottles, they fashioned altars that were models of African heaven. Theirs was the work of artists. "Frozen waterfalls" and "dances for the eyes" is how David Byrne, Afro-Latin rock musician and all-around man of the postmodern arts, describes altar assemblages. Byrne compares the sacralized detritus arranged on Caribbean altars to "visual jazz, constantly reworked and reactivated." For him, altars are played like musical instruments. Like jazz compositions, they are revised and augmented through constant use. Their aesthetic is improvisational. They can never be "finished" (Galembo 1993: vii).

This jazzy tradition of improvisation ultimately links the fabrication of a Haitian Vodou altar—through permutations of time and space—to an Antillean aesthetic famously described by Derek Walcott : "Break a vase, and the love that reassembles the fragments is stronger than that love which took its symmetry for granted when it was whole. . . .This gathering of broken pieces is the care and pain of the Antilles, and if the pieces are disparate, ill-fitting, they contain more pain than their original sculpture, those icons and sacred vessels taken for granted in their ancestral places.

Antillean art is this restoration of our shattered histories, our shards of vocabulary, our archipelago becoming a synonym for pieces broken off from the original continent" (1992: 2).

Barra works within the artistic tradition described by Walcott. His skills are essentially those of an altar maker. He once referred to the objects he makes as "little altars," though this term must be understood in the highly specialized context of the kinds of materials he uses and the gods he was chosen to serve. His "little altars" are hardly for everyday use. They do not please everyday gods nor attract everyday customers. I have never seen his Vodou Things adorn any altar, including those he constructed for his own basement ounfò in Croix des Missions. For whom, then, does Barra work? He tells us plainly: for the spiritual masters of his head and for customers he screens in his dreams. By his own word and deed, he is both visionary and futurist. He realizes his visions in objects from the market, and then dreams a market they will someday attract. Since Pierrot Barra spends most of his time in that dream world, he must depend on Marie Cassaise to see him through the everyday one in the Iron Market.

Even though his sculptures are sometimes very large, Barra works essentially as a miniaturist. He must compress his immense visions into small spaces, like the "little house" he made for Gede, child of

22

the Baron Samedi (plate 11). In this miniature altar, "broken pieces" are arranged "so that Gede might have a place to live" (when not lurking in a tomb or riding his horse). As Barra explained, "The bottle is for Gede. When Gede gets the spirit he wants whiskey and pepper. If a true spirit comes and you don't give him the bottle, the spirit is gone. All of these things—plastic flowers, evergreen, red ribbons, pine cones, ornaments, crucifix, chromolithographs, skull—are for people who are buried. I use these things like the wreaths white people put on graves when their people die."

Like the trickster god of death and sex honored in this altar, Barra's work is unbalanced. It is kinetic, meant to energize the hot Petwo lwa who is master of his head and his left hand. Petwo means action—especially magic action—and that is what Barra's work looks like to many people, in Haiti as well as out of it. "Black magic," one young Haitian complained to me after I showed slides of the work in Miami. "This is the evil side of Vodou, and should not be mixed up with the family gods whom we serve."

"I couldn't agree less," I replied, and repeated what one manbo friend had told me: "Though I serve with only one hand, it is good to have the other hand there for the time someone slaps you in the face." A division between the "good" Vodou (Rada) and the "evil" Vodou (Petwo or Bizango)

does *not* exist on the ground. To survive in Haiti, both hands must work.

But the objections of the man in Miami raise another important question: What is the function of this art—for Barra and for his customers? Barra's answer is again clear: he is a magician who makes magic art. "I work only for *Mystique*," he said. "If I worked for commercial, there would be a lot of people to come and buy. I make my pieces for particular reasons. Anybody could buy them, if they like, for pleasure, though they are not made for commercial." But white people have been buying his work, some for more than a decade. When I asked why he thought they were buying these Vodou Things, Barra replied, "White people come to buy these pieces because they are *Mystique*. You don't have to be an oungan to be *mystique*. [*Mystique*] is not just for Vodou. It's for the world Vodou."

Barra believes that, even if most white customers do buy his sculptures for purely (western) aesthetic or speculative reasons, the nature or quality of the pieces' mystic effectiveness is not changed. He made clear that even the naive owner of a Vodou Thing would be protected by its power as a *gad* (a spiritually charged object or spirit which can be bought or hired for service or protection): "Sometimes you are afraid that things might hurt you. Then you can buy these [Vodou Things], even if you don't have mystic knowledge. It helps. It protects the house. Everywhere you go in

23

your house, it follows you. But you must keep it cool. Just keep it cool, and it will follow you everywhere. If a thief comes and sees [my Vodou Thing] he will be afraid, because it's something he's never seen before. When a thief comes and sees the face of the djab, he just runs away. So you can stay in your house for twenty years, and never see anything happen."

This explanation helps clarify why Barra's sculptures don't appear on his own altars. They would be redundant there. As gad, they attract and channel the energies of specific lwa. They reduce and compact the multiple purposes of an altar to specific transformative ends. Within the traditional categories of religious art, they are wild cards that change the rules of the game. Like most magic, the context of the gad is personal, not social. They work only under contractural obligation. So Barra's sculptures serve as personal altars (rogatwa) for their owners. Since they serve private ends, they need to be maintained in private places rather than in the public space of an ounfò. For similar reasons Barra's neighbor, the celebrated painter Andrè Pierre, does not place any of his own portraits of the lwa on his altars. When I asked him why not, he said the lwa prefer simple things. Portraits are for humans, liquor and cigarettes for the gods.

There are stylistic implications that arise from the magical function of Barra's sculpture. Although divine tastes are indeed eclectic, they are regulated by a traditional order (regleman) which determines precedence in the arrangement of altar objects. To each lwa belong certain colors and styles, certain correspondences with the imagery of Catholic saints and indeed with other lwa. This regleman structures the apparent clutter on an altar, and is part of the secret knowledge of Vodou initiates. But as hotter categories of Vodou divinities are invoked, from Petwo to Kongo to Makaya to Bizango, the regleman loosens up. More unrestrained powers and violent energies demand more dramatic juxtapositions in material representation. As oungan Wilfred Ignace said when tipping a bowler hat onto a human skull fixed atop a Bizango cross, "There really are no rules of representation when Vodou gets this hot." Yet even within the aesthetic range open to those who serve the hot gods, the liberties Barra takes are breathtaking. He avails himself of images and objects of power associated with the Petwo regleman, and then incorporates some market commodity where no one had ever found a divinity before. Even in a tradition open to Pentecostal renovations, he is a revolutionary.

Reposwa From the perspective of form or function, it is very difficult to define categories for Barra sculptures. In form they mirror the constellation of objects on a Petwo or Bizango altar, with some indeed being miniature altars. In function they may

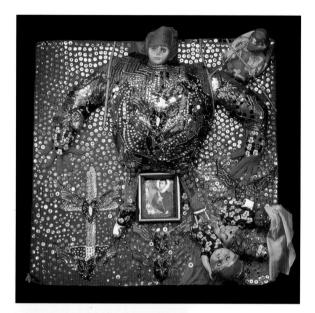

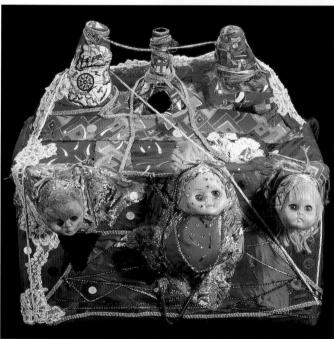

Above:
"The Mickey Mouse patches are djabs. The babies' faces are djab spirits and they are controlled by the big djab."
—Pierrot Barra

Left:
Barra's homage in glass, plastic, sequins, satin, lace, and synthetic diamonds to the spirit of the twins (Marasa), who are depicted as three rather than two, signalling surpassing abundance.

25

also serve as reposwa, a generic term for any object which contains a lwa. A stone might be a reposwa, but so, too, might a house. Marie Placide de la Rosaire, a woman who lives near the Vodou shrine site of Sodo, once conducted Henrietta Cosentino and me on a tour through her living room, which she described, with surprising aplomb, as the reposwa of the Most Holy Trinity. Reposwa, however, usually references objects more modest in size and content.

Barra's reposwa are physical vessels made to contain spirit powers. As such they function like Catholic reliquaries containing, often in some base material form (a bone, a bit of cloth, a nail), the power of a saint. Consider the reposwa Barra constructed from small animal horns, bejewelled dolls, spangles, and a holy picture of Petwo-Jesus with a triple-rayed halo, for Bosou Twa Kon, the Triple-Horned Bull of the Petwo pantheon (plate 12). Recalling the spirit-catching glass sometimes embedded in the belly of nkisi, he has set a mirror into the middle of this strange collage. According to Barra, the spirit of Bosou (who he says is not really a bull, but a spirit who likes to eat beef) "reposes" in back of the mirror. If appropriately summoned, Bosou will project onto the surface of the mirror an image of his next victim—acting in this manner like the mirror so vengefully employed by the Wicked Queen in "Snow White."

As sold in the Iron Market, Barra's objects are only *potential* reposwa. They await sacral insertions, like Kongo nkisi without their empowering bundles of cemetery dirt, or the china *soperas* of Santería not yet suffused with oiled stones of the saints. In order to be so empowered, reposwa must be baptized. As Barra explained, "After you make the [Vodou Thing] you bless it. Then you baptize it and it becomes a reposwa. A reposwa is a place of silence. It is like a little temple (*ti ounfò*)." I have not seen Barra perform such baptisms, but any manbo or oungan could do the job.

Following are Barra's descriptions of reposwa for Santa Marta and Black Ezili Balene (plates 13 and 14). It is apparent from his words, and more especially from their shapes, that these sculptures house very dangerous spirits. Often they are devils (djabs), the generic name for the foot soldiers of the Petwo and Bizango gods. More than simply acting as protective gad, these reposwa function as wanga meant to search out and destroy their owners' enemies in a hard and terrible world. They are repositories for the left-handed snake gods of whiskey and blood, made manifest in violent shapes and colors and in the extreme eclecticism of their armories.

"Santa Marta": She is one of the big djabs who comes from Santo Domingo. Santo Domingo is a mystic country, the same land as Haiti. She works with a

26

snake when she comes out. She runs the snake all over. The snake works the same as Damballa Flambeau, but it's more hot than La Flambeau. It's bigger than that. Bizango can't stop him. *Shanpwel* can't stop him. Santa Marta has a child. A djab who never gives his name. Only his wife knows. The spirit only listens to him. If he told her 'Don't do something,' she wouldn't do it.

They are on a bridge, or something like a piece of mountain. They control it. Nobody can come near. No Haitian ever had this spirit. If someone had it, I've never seen it. I saw it in a dream. I always see it in a dream. If you stay till the end of the month, I will let you see the spirit. When it comes, you will see snakes around it. Big snakes from there to there. Maybe this week. I will send someone to tell you. I will let you see this spirit.

"Black Ezili Balene": When she is mad, she always wants to drink blood. After you call her, she has to drink blood. If you just stick your hand out she won't kill you, but she has to drink your blood. Or else give her the blood of the pig or the goat. Just bring it in a cup, and she drinks it.

If I want to get rid of you, I call this one. If I want to get Georges, I say, "Get Georges for me tomorrow at ten o'clock" and at ten o'clock tomorrow he will die! This is the job she's doing.

To discipline people. If my wife gives me problems and I want her to leave, I just say, "Go get her." You can buy this spirit, or rent it for a certain time. It goes and does the job, and then it comes back. It is Petwo. They do what they want. They can turn into goats. They can all turn into animals. Or they can turn *you* into a goat. When she's coming to get you, you might see a chicken walking on the street. But it's her. When she comes and bites you, you're gone.

Mojo Boards Barra's early compositions are mostly freestanding, but much of his current work is in a medium for which I have coined the term "mojo board" (Cosentino 1996b: 27–28). The genre had not been previously named, so I considered such ingenious neologisms as pak-o-mojo, MO-JO-PAK, and mojo-matic (all suggested by folklorist Victoria Simmons) before settling on the plainer term. The word "mojo," of course, refers to such good luck charms as rabbit feet, conqueror root, or Indian medals which are used to conjure and protect in the Hoodoo cultures of the Mississippi Delta (and much of America beyond). Like his African-American counterparts, Barra seeks out Iron Market "mojos" (speedometers, headlights, barbeque forks), which he then juxtaposes to his inevitable doll parts on cloth-covered boards.

This new kind of sacred art has no direct Haitian analogue, but seems materially and conceptually related to popular Afro-Hispanic sacramentals available in botanicas across the United States and in such emporia of Afro-Latin religious art as Tijuana and Acapulco. In their Latin incarnations, mojo boards often incorporate horseshoes surrounded by smaller sacred items such as lithographs, statuettes, flowers, and herb bundles. The horseshoe could function independently as a mojo, but, when reconstellated, it is described in botanica catalogues as "fixed" (according to folklorist Steve Wehmeyer). Such "fixed" compositions are then shrink-wrapped in plastic, ready for hanging in some appropriate private or commercial space. Although there is no evidence that he has seen these other mojo types, Barra has considerably expanded the fixed board concept in style, content and form.

Mojo boards express the Barra aesthetic at its most eclectic. Consider "En Danger de Mort," a red board with silver crosses, detached doll heads (including a Cabbage Patch Kid), a whole doll with silver hair, a speedometer, a tachometer and various spangles (plate 15). Explaining its mystic significance, Barra says, "This is one of the djabs who goes fast when she runs. Her name is 'Danger of Death.' The speedometer makes her go fast. She never stops . . . you think she's not going to kill you, and *boom*—you're dead." Concerning

the headlights he has attached to another mojo board he calls "Kongo Savanne," Barra says, "The headlight shines when the djab is coming. Its eyes are open. The light is coming from the djab. I put the light on to show how the djab sees at night. His eyes have more light than this light. He sees all, but only at night. At midnight."

In what may be his mojo masterpiece, "Cross with Spoon and Fork" (plate 16), Barra has assembled his trademark messenger lwa—whole bodies, heads and assorted limbs of dolls—around a black cross, emblazoned with sequins, lace and ribbons. The cross which bifurcates the board is a prevalent symbol in Vodou, but a symbol of what? And why the huge, festooned fork and spoon veering off from its foot? Barra explained: "This cross is for Bawon Criminel, a good friend of Dantò. Bawon Criminel is one of the big chiefs in the Petwo line. He works with Ti Jean Petwo, Marionette, Ezili Dantò, and Simbi-An-Dezo. Bawon Criminel is a justice. If you're right, you won't meet him. But he's always there, waiting to dig with the fork. If a person is taken to meet the Bawon, he is turned into a pig. The fork and spoon are used to eat the meat. There is no knife."

Criminel, the master of this mojo, is a particularly ghoulish member of the Baron Samedi family. He is custodian of the cemeteries and captain of the zombies, those pathetic soulless victims of Bizango's harshest enforcement: the transformation of those

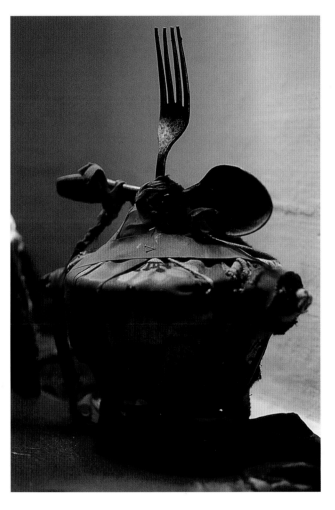

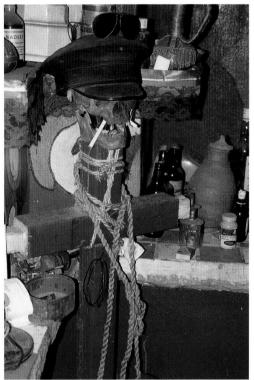

Above:
A cross for Baron Samedi set in the Petwo altar of Ednaire Pierre, Port-au-Prince.

Left:
A Kongo Paket with crossed spoon and fork to "feed" the Petwo *lwa*.

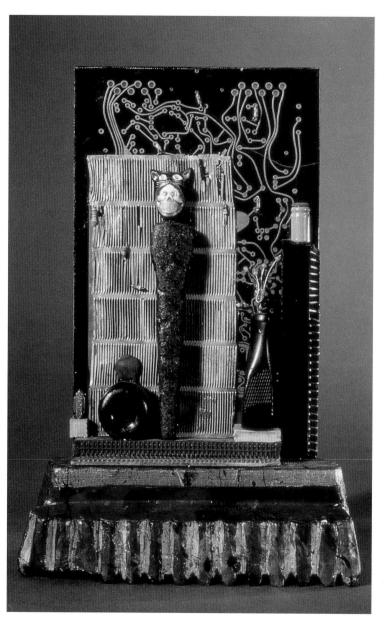

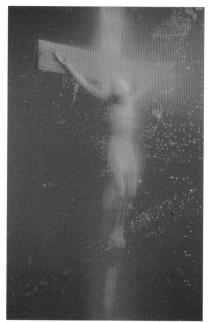

Above:
In his notorious photograph, "Piss Christ," Andrés Serrano drenches a plastic crucifix in the transforming fluid of his own urine.

Left:
Los Angeles artist Betye Saar's mojo board masterpiece, "Guardian of Desire."

30

it condemns into the walking dead. Like all the members of his family, Criminel is symbolized by the cross. But we must be careful in our hermeneutics, for Barra has told us this Christian symbol is not a sign of redemption. It is an object of judgment and moral intimidation. It must be seen in conjunction with the spoon and fork, implements of the Petwo deities who do not eat with their hands like ordinary Haitians or the family gods of Rada. They eat with tableware as the French colonials did, and in some ways are as foreign and intimidating as the old slave masters. Note that the Kongo Paket, a Vodou ritual object meant to evoke their powers, may also be surmounted by a crossed spoon and fork. With his secret society connections, Criminel acts as a sort of divine mafioso, the enforcer of last resort: powerful, rich, cruel when necessary, but, above all else, effective. The mojo board blinks *Beware*: if your life is swinish, Criminel will eat you like a pig.

Barra's cross resonates across five hundred years and six thousand miles to the "Four Moments of the Sun," a name given by Robert Farris Thompson to the cruciform which dominated the sacred arts of Kongo, one of Vodou's parent cultures. In the four limbs of the crucifix brought to Kongo by Portuguese missionaries in the fifteenth century, African artists came to recognize a prime symbol for their own belief in the recycling of the human soul.

This Kongo process of assimilating the crucifix has been described by Georges Balandier: "The [Kongo artists] assimilated [Christian imagery] according to their needs and the rules of their logic. . . . Crucifixes and holy statuettes became snares for benign forces, instruments favorable to fecundity and fertility. Crosses were used in magical operations, especially in rituals ensuring the safety of the hunter and the success of his expedition. . . . In Loango the cross was associated with symbols representing the elements, as Christ and the Virgin were associated with Bunsi, the divinity of the Earth. It also appeared in the home in the form of 'fetish nails,' which had a protective function"(1968: 241–42). Thus there is a final lesson which must not be lost in considering the iconography in Barra's "Cross with Spoon and Fork," a lesson first learned five hundred years ago in Kongo: Catholicism did not eclipse the sacred arts of the African-Atlantic world; it expanded their symbolic range (Cosentino 1996b: 29). With that lesson in mind, we might better approach the work of artists such as Betye Saar or photographer Andrés Serrano, who reshape traditional Catholic imagery into contemporary African-Atlantic art.

31

Going Places

[M]odern ethnographic histories are perhaps condemned to oscillate between two meta-narratives . . . one of loss, the other of invention. In most specific conjunctures both narratives are relevant, each undermining the other's claim to tell "the whole story." . . . In the last decades of the twentieth century, ethnography begins from the inescapable fact that Westerners are not the only ones going places in the modern world.

James Clifford

I returned to Haiti in June 1996 for what I considered my "au revoir" visit. The Vodou exhibition and book which I had worked on for most of a decade were out, and both had achieved some acclaim. Barra had been an important part of their success. His assemblages were featured in various parts of the exhibition, including the section called "Vodou as Inspiration," where they were juxtaposed to the paintings of Hector Hyppolite and the iron sculptures of Georges Liautaud (undisputed geniuses of the postwar Haitian [art] renaissance), as well as to the flags of Antoine Oleyant and the surreal paintings of Edouard Duval-Carrié, both contemporary artists with wide recognition in the world art market.

Barra's devotional installations stood out in sharp contrast to these other masterworks. They seemed cruder in execution, but more kinetic, unrelated to any Vodou tradition other than altar assem-blage. Besides, they were difficult to classify. Were they really "art" or merely the votive objects of a repellent religion created by some demented magician with a penchant for dismembering dolls? A visiting teacher complained that "The Escort of Ezili" (plate 10), with its disembodied heads and severed foot, was the stuff of nightmares. A visiting Jesuit priest, however, was riveted by the same piece. For him, Barra's overstylization corresponded in eerie ways to the extreme theatricality of Counter-Reformation art, including plaster statues of ecstatic saints with flayed skin and gouged-out eyeballs, which were staples of every Catholic chapel before the prelates at Vatican II (1962–65) abandoned that whole visual tradition to Vodou and American popular culture. After all, Barra and the manufacturers of Catholic popular art were inspired by a similar desire to ferret out transcendence in even the most secular aspects of material culture. With their melodramatic chromolithographs and gaudy plaster statues, Catholic merchants were anxious to promote the sale of their own gods in as many emporia as possible, including the Iron Market in Port-au-Prince, where their wares continue to command a large clientele.

Barra's museum installation also set off reverberations in more immediate markets. In New York, *The Village Voice* called the exhibition catalogue "the one art book you could not do without this year." The

Sunday *New York Times* (February 4, 1996) ran a long adulatory review of the exhibition, illustrated by Barra table coffins with glass windows and plastic skulls. Suddenly Pierrot was famous. At New York's Outsider Art Fair, which opened as these reviews appeared, two longtime dealers in Haitian art were selling Barra at prices which would be competitive in SoHo, not in the Iron Market.

Aware of my role in introducing Barra to this demimonde, I wrote a pensive editorial in *African Arts* (1996b) bemoaning the unintended effects that curating a folk art exhibit could have on Yuppie art lust. But in my angst, I had overestimated the reception Barra's work would receive in the Outsider market. Both art dealers quickly let me know that any gloom over their commercial success was premature; neither had sold any Barra sculptures. Randall Morris, who runs a SoHo gallery, faxed me a reminder that (A) yuppies no longer exist; (B) he had admired and been collecting Barra pieces for many years before the show opened; (C) he has yet to sell any of his Barra collection. Christiane Bourbon and Renald Lally, who run a gallery of avant-garde Haitian art in the swank Port-au-Prince suburb of Petionville, likewise told me that they admired Barra's work but didn't think it was what their customers wanted. Haitian collectors prefer romanticized paintings of happy peasants or sunlit colonial scapes. Crucified dolls

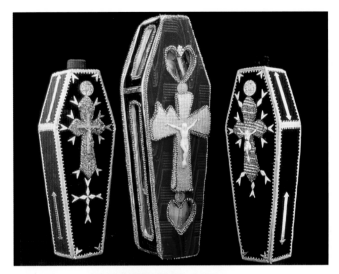

Above:
Barra's table coffins

Left:
Melodramatic chromo-lithographs promote the cult of the saints in the Iron Market.

33

don't tempt them or most American collectors, who are interested in paintings from the Haitian renaissance or from artists who paint in the celebrated idiom of the black avant-garde created by the Nuyorican-Haitian Jean-Michel Basquiat.

But that judgment, too, may be premature. In May 1996 I received a postcard advertisement from the gallery of Selden Rodman, a distinguished scholar and dealer who has been a tastemaker in the American market for Haitian art for over half a century. Illustrating Rodman's card was a sequined and jewelled purple cross adorned with dolls' heads, plastic Christmas wreaths, a floral china plate and various spangles, all affixed to a black cloth board (plate 17). Rodman was using a classic Barra mojo board to advertise his exhibition of already-celebrated Haitian artists, including Lionel St. Eloi, Serge Jolimeau, Gabriel Bien-Aime, Lafortune Felix and Louisiane St. Fleurant. That Barra's work appeared on the postcard meant that he was indeed now famous, even if only for fifteen minutes, and with no proven market.

Barra was not unaware of these distant encomiums. Shortly after I greeted him on the verandah of his mother's house near the Iron Market, he pulled from his pocket the *New York Times* review with its illustrated coffins. A foreign customer had brought him the clipping. To this, I added a copy of the exhibition catalogue and the latest *African Arts* (1996b), which featured his "Spoon and Fork" mojo on the cover. His pleasure was apparent, as was Marie Cassaise's, whose eyes misted at these bewildering celebrations in print. Barra also showed me a plastic bag full of pills which another customer had brought him for his heart. He was suffering from some coronary distress, and had retreated to this verandah, where he now maintained his atelier. He said he felt better, but had decided to leave the stress of marketing to Marie Cassaise. Both she and Pierrot were at present being vexed by an artist who was turning out Barraesque assemblages at a stall across from them. They had apprenticed this imitator before he turned independent, and so had created their own Frankenstein.

While sitting on the verandah I learned more about Barra's life and the production of his art, subjects I had not thought to ask him about earlier, and which he had felt no need to explain. I noticed several women working around the verandah. Georges told me they were *plase*, the Kreyol term for the women a man maintains outside his main or regular ménage. As I now found out, Pierrot keeps eight or ten such women, with whom he has fathered twenty or thirty children. In addition to these plase, Pierrot and Marie Cassaise are assisted by their children, especially Roland, a favored younger son, and Franz, the eldest, who had begun to produce his own line of

34

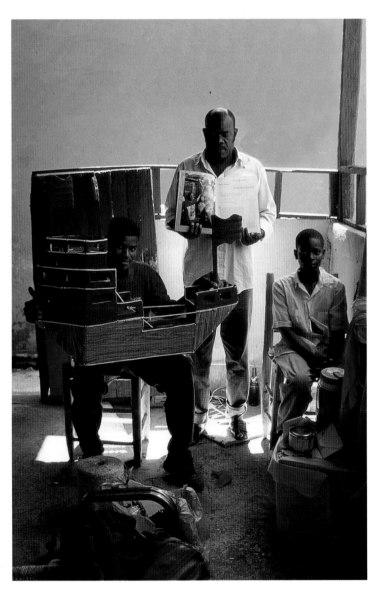

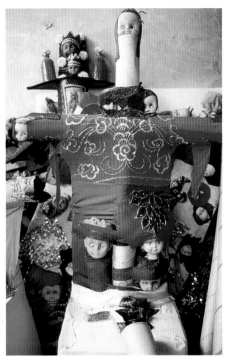

Above:
Barra's verandah floor covered with mojo boards in various stages of construction.

Left:
Pierrot Barra with his sons Franz (right) and Roland, celebrating himself in print.

35

mystic sculptures on the side. That day six or seven children and plase were carrying out Pierrot's designs. The verandah floor was covered with mojo boards in various stages of construction: strips of cloth, a doll covered over with black filmy gauze, jumbles of bottles, crosses, boxes—materials being used for twelve or fifteen objects which Pierrot had designed, and which the family crew was putting together. With all those apprenticed hands realizing the master's vision, Barra's verandah ménage resembled the studio of a Renaissance artist.

Flashes of Pierrot's genius for juxtaposition were visible on mojo boards in various stages of construction. A plastic head of Bugs Bunny grinned under a coaster advertising Löwenbräu beer (plate 18). Multiple cutout images of a moustached sword swallower embroidered a fabulous sequined butterfly (plate 19). I asked Pierrot if the sword swallower and Bugs Bunny signified any particular lwa. He assured me that they were simply manifestations of mystic Petwo power. It may be that their mystic power was even greater than he imagined. I had read in the *Los Angeles Times* that a Japanese department store, anxious to deck out its vitrine in appropriate Easter decor, had featured a bunny nailed to a cross. Ecstatic Christian symbolism seems particularly vulnerable to such startling transpositions, as Barra's sculptures make abundantly clear.

There were also new object types on the verandah. A finely wrought cruciform altar balanced bottles on each arm, with red Indian heads suspended from gold chains on the top (plate 20). Little coffins with dolls' heads pressed against peekaboo windows (plate 21). Both coffins and crosses were wrapped in some sort of shiny green synthetic newly available in the market. Other altar pieces and reposwa repeated the idea of the anthropomorphic cross over and over again (plate 22). Sometimes doll heads seemed fixed to mojos simply for the shock value, the way Federico Fellini came to throw "fatties" and "weirdos" into his movies because audiences expected to see them there (plate 23). Barra was still running on fresh visions, some more singular than ever. But the strain of producing for new customers and new markets was also apparent.

Motherlode

The filth that an expansive West . . . has thrown in the face of the world's societies appears as raw material, compost for new orders of difference. It is also filth.
 James Clifford

This presumed history of a folk artist underwent a yet more serious revision when I visited the home of Marianne Lehman in Petionville the next day. Mme. Lehman, a Swiss national and longtime resident in Haiti, has compulsively amassed what is

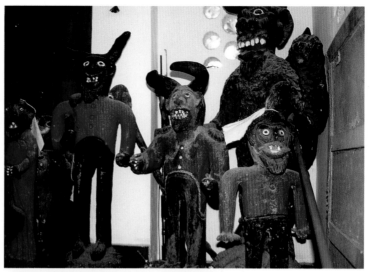

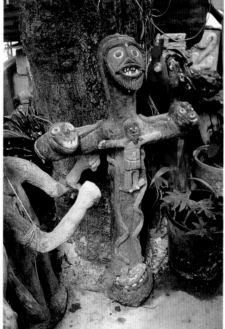

Above:
Armies of concrete "devils" fill room after room of the Lehman house.

Left:
A Kongo-inspired cruciform sprouts humanoid skulls in the Lehman garden.

Far left:
A Kongo-inspired horned "devil" resides in the Lehman garden.

37

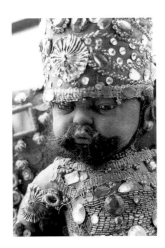

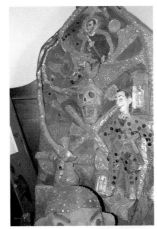

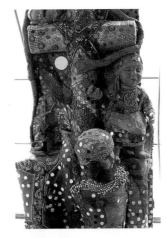

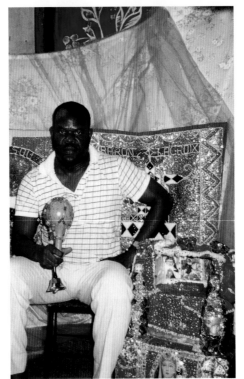

Above, far left:
An exquisitely encrusted St. Jacques with a beard growing from his rubber doll's chin.

Above, middle:
A somber mojo board for Baron Samedi, with the traditional image of St. Gerardo juxtaposed to a grinning head of Pee-Wee Herman.

Above right:
A cross made of dolls ingeniously entwined by a draping snake.

Left:
Pierrot Barra posing with his sacred *asson* in the Iron Market

probably the world's most impressive—and eclectic—horde of Vodou temple arts. Her home is an Ali Baba's cave of pots and bowls, friezes, drums, flags and especially statuary—massive representations of the lwa in wood and concrete and fabric, huge horned djabs painted in red and black, life-size crosses sprouting human skulls. Room after room in her home is lined and crowded with these astounding figures. Most of the pieces were brought to Lehman's door by middlemen who claimed to have acquired them from a small number of temples in the period following the 1986 *dechoukaj* ("uprooting") of Jean-Claude ("Baby Doc") Duvalier's despised regime. Many of the pieces are of doubtful provenance or authenticity, but others open vistas into the various sacred arts of Vodou previously unseen by most scholars—or practitioners.

Mme. Lehman has generously allowed me to see and photograph her collection whenever I am in Haiti. On this visit I was arrested by several pieces she had recently acquired that looked hauntingly familiar, including a cross made of dolls ingeniously entwined by a draping snake, a somber mojo board for Bawon Samdi, with the traditional chromolithograph of St. Gerardo juxtaposed to what resembled a grinning head of Pee-Wee Herman, and an exquisitely encrusted St. Jacques, with a beard growing from a rubber doll's chin, rampant on a mojo board. She said these and similar pieces had been delivered by her regular runner Toto from a temple in Santo Domingo. To me they looked like a motherlode of splendidly wrought Barra sculptures. But they were demonstrably old, certainly older than seven years, which, according to Barra, was how long he had been making Vodou Things. And they purportedly came from a temple, the first evidence I'd seen that his art had been put to such ritual use. I asked Marianne if I might bring Pierrot and Marie to see these new pieces, and she happily agreed.

Georges René made all the arrangements for the trip. We took a taxi to Barra's place and then waited in the heat and traffic for an hour while he finished his toilette. He sent to the dry cleaners for clothes and then for shoes two sizes too big. In exasperation, Georges shouted that Pierrot was *un sot* (a complete child)! The charge is accurate, I suppose, though Pierrot's art does seem congruent with his eccentric behavior, his clothing, and his reversal of a Mohawk hair style, with its shaven swath neatly cleaving his skull. Many oungans effect eccentric behavior; it's part of their manifest power. But none I've met cuts such a protean figure. When Pierrot finally did emerge, in blue guayabera, white pants and brown Italian loafers, he looked a lot better than any of the rest of us. Marie followed in a dark blue dress, looking as plain as a hen in the wake of a fighting cock. When they started for the taxi,

she grabbed his hand. Her reach spoke of love but also of protection. She was helping her enfant terrible to cross the street.

As the day progressed our ricocheting conservations took on the surreal quality of a Columbian dialogue. In Haiti one comes to wonder what Columbus's sailors said to the Taino after they shipwrecked near Cap Haitien in 1492, or what the Taino said back. Set free from a common language or culture, each side must have imagined the content of a dialogue that may never have transpired. Mutatis mutandis, what did the taxi driver make of my fractured Kreyol, or any of us grasp from Georges René's sketchy cross-translations from Kreyol to French to street-hustler English? How much did we understand Mme. Lehman, as she toured us through her vast and strange collection in various registers of three languages? Pierrot seemed as stunned by this babble as he was by the profusion of djabs which stared out from every corner of the house. Marie Cassaise and Marianne Lehman, however, were on firmer ground. They had had their Columbian encounter sometime earlier when Marie had knocked on the door trying to hawk some of Pierrot's pieces, fruitlessly as it turned out, since Mme. Lehman explained that she collected only "old and authentic" Vodou art!

Pierrot finally smiled after we had snaked and stumbled our way to the pieces I had brought him to see. Yes indeed, they were his work. He had sold them a while ago to Toto, Lehman's middleman, who said he was buying these Vodou Things for an ounfò in Santo Domingo. The apparent age of these sculptures pushes back their fabrication to a time when, as I had understood it, Barra was only helping his mother make flags. He couldn't remember exactly when he had made the pieces; perhaps it was ten or fifteen years ago, when his son Franz was small. Marie Cassaise was already assisting him then. She had pasted that inspired beard on the wizened troll-like face of the rampant St. Jacques.

Our conversation at Lehman's house scrambled "facts" I thought I had gleaned in my earlier interview. Evidently Barra's career as a sculptor had begun while he was apprenticed to his mother. And he had found an avant-garde market for his work before any international attention had come his way. I should not have been surprised by these revelations. The answers to what I thought had been a straightforward series of questions constituted a life story highly selective in detail and contingent upon the circumstances of my inquiry. Another occasion and different questioners would no doubt produce other "facts," or interject new characters, into the tale of Pierrot Barra's life. It was better to focus on the works, where the only hard evidence lay. But, for that very reason, the newly discovered sculptures in the Lehman collection were also an epiphany. They

seemed more individually conceived and executed, without the formulaic use of dolls and sequins that marked much of the work I had noted on his verandah the day before.

What is happening to the production of Barra's Vodou Things? Was I seeing the work of an enfant terrible being "dumbed down" to meet the demands of foreign customers? In part, the answer is yes. A larger market has involved children and plase in the construction of sculptures which are really delicate illusions. With wisps, fluffs and loops of glittery stuff, Barra creates trompe d'oeil the very physical integrity of which depends on the delicate placement of a hundred pins. Only the imagination and hands of an artist can assure the transformation of such random junk into reposwa for the gods. With a growing clientele, that hand is sometimes distanced and sometimes gone.

But "dumbing down" is not a definitive story either. Two new Barra sculptures turned up in the Chicago Field Museum gift shop in January 1997. They were made from the same glossy materials I had observed him using the previous June. Both sculptures were brilliantly conceived and exquisitely wrought. In one (plate 24), a blue-eyed doll rises from her blue-sequined bottle on butterfly wings, like those wings to which he had earlier attached mustachioed sword swallowers (plate 19). Another doll nestles in the corner of the but-

terfly wing, her foot peeking out from under a silver rose like that provocative pwen in "The Escort of Ezili" (plate 10). In a second reliquary (plate 25), sister dolls in gorgeous bangles and satin roses and holding a miniature Vodou flag rise out of a wine-red bottle. They are ko-drapo, the twin flag bearers who salute the deities at the opening of every ceremony.

In both of these splendid pieces Barra lightly dusts his dolls' faces with glitter. Largely missing from his earlier work, glitter, sequins, glossy stickers, and Mardi Gras beads now often drench Barra's pieces, sometimes obscuring the images underneath. When used lightly, the glitter can be enchanting; when it is applied heavily, the effect is carnivalesque. Evanescent sparkle replaces significant form. Glitter is Barra's new metier. It is the dividend paid back to a foreign market he seeks to please, but can never directly know.

Boom and bust in the sequin market tells an instructive Vodou tale. Flag scholar Susan Tselos (in conversation, 1996) has discovered that masses of sequins were imported into Haiti during the regime of Baby Doc, when American fashion designers set up floating offshore sewing factories. After the 1986 dechoukaj the American designers pulled out, leaving their sequins behind. Abandoned sequins were soon encrusting Vodou flags, especially those being sewn for a developing international boutique market. The sudden availability of cheap se-

Famed designer Gianni Versace transforms sequined Vodou flag imagery into high fashion.

41

quins thus created a new genre of Vodou art. Too heavy to unfurl in ounfòs, these boutique flags were perfect for hanging as folk art in American apartments. They even inspired a new fashion line by the ever-resourceful designer Gianni Versace. An American embargo against the despotic military regime of Raoul Cedras (1991–94) changed all that. Imports were stopped by American warships, and the once-abundant sequins became scarce and costly. Flag makers tried substituting small plastic disks (the so-called "embargo sequins"), or alternatively, tube beads. The results, however, have been fairly execrable, and by 1996 a flourishing boutique market was drying up.

The Lord giveth and the Lord taketh away. That theological precept is also the first law of Vodou economics. Since they were exported from Africa as prime commodities in the grotesque commerce of slavery, Haitians have had little control over the subsequent development of their own import or export markets. Commodities appear as if by magic, and then disappear with the same illogic. No wonder they are fetishized. First it was Catholic images and Masonic regalia abandoned by French slave masters. Now it is dolls found in dumps and sequins left behind by fleeing couturiers. In an island stripped of forest and factory, imported items and ready-mades are perforce the raw material from which all art and religion are derived.

Pierrot Barra and Marie Cassaise are the inheritors of this entire history. They work in the market and respond to its fluctuations. Out of materials delivered to them they locate their gods. When there are sequins, the lwa shine. When there are dolls, they grow rubber arms. When there are speedometers, they run fast. Barra and Cassaise mix and match castoffs from the eighteenth through the twentieth centuries with a breathtaking insouciance. Their disregard for the linear is complete. For them, the Virgin Mary nestles easily with Bugs Bunny. In one of those ironies that always seems to mark the barter between black and white worlds, the style of these Haitian folk artists now adumbrates both ends of the fine art/outsider avant-garde in Euro-American art.

At the low end of a dichotomy (which more and more resembles a continuum) shines the Bottle Village of Grandma Tressa Prisbrey, an architectural fantasy fabricated from recyclia hauled out of the Simi Valley, California, town dump. Prisbrey's fodder closely resembles products dumped into the Iron Market. "[A]s a builder she was partial not only to bottles but also to lamp shades, lipstick cases and television tubes. Like the trout, she seized upon anything that glitters" (Brown 1997: B8). Her preferred building blocks would seem awfully familiar to Barra and Cassaise. "The prismatic world she created out of bottles—their necks facing outward to achieve a glistening stained glass effect

42

inside—included a Doll House for her 550 dolls, a Round House with round furniture and a jingly fireplace made out of intravenous feeding tubes" (Brown 1997: B8).

Admirers of this "no-deposit, no-return" architecture do not include those Simi Valley citizens who are presently fighting plans to restore Prisbrey's earthquake-damaged wonder with federal monies. Ironically they advocate bulldozing this folk monument at the very time that so-called "outsider" art is attracting great critical attention and collectors' dollars. Perhaps no "outsider" is more highly acclaimed among high art critics than New York miniaturist Joseph Cornell, whose tiny box-altars inspired this panegyric from Charles Simic: "[T]hat art of reassembling fragments of preexisting images in such a way as to form a new image is the most important innovation in the art of this century. Found objects, chance creations, ready-mades (mass-produced items promoted into art objects) abolish the separation between art and life. The commonplace is miraculous if rightly seen, if recognized" (1993: 18).

Cornell's assemblages are now considered ironic and fashionably labeled postmodern. Pierrot Barra and Marie Cassaise might similarly be called postmodern, so long as it is understood that in Haiti postmodernism began as soon as African slaves were sold into the grotesque world of French colonialism. Without ever experiencing the processes of modernism,

Tressa Prisbrey's constellation of dolls at Bottle Village in Simi Valley, California, would look familiar to Barra and Cassaise.

Haitians necessarily understood the prefabricated products of the modern world as "signs" of another order of existence. Ripped from a continuous history, their altar arrangements and ritual performances have been perforce synchronic. With X-ray precision, Pierrot Barra and Marie Cassaise discern the Real Presence of the lwa in the most improbable simulacra, where they have always been lurking. In their Vodou Things we, too, may discern gods in the market, even and *especially* as we belatedly follow them into the commodity fetishism of our own brave new postmodern world.

43

Balandier, Georges. 1969. *Daily Life in the Kingdom of the Kongo.* London: George Allen & Unwin Ltd., 1968. Reprint, Cleveland: Meridian.

Blier, Suzanne Preston. 1995. "Vodun: West African Roots of Vodou." In *The Sacred Arts of Haitian Vodou,* ed. Donald Cosentino, 61–87. Los Angeles: Fowler Museum.

Brown, Karen McCarthy. 1991. *Mama Lola: A Vodou Priestess in Brooklyn.* Berkeley: University of California Press.

Brown, Patricia Leigh. 1997. "Reading the Message in the Bottles." *The New York Times,* February 6, B1–8.

Clifford, James. 1988. *The Predicament of Culture: Twentieth Century Ethnography, Literature, and Art.* Cambridge: Harvard University Press.

Cosentino, Donald. 1996 a. "Madonna's Earrings: Catholic Icons as Ethnic Chic." In *Recycled Reseen: Folk Art from the Global Scrap Heap*, ed. Charlene Cerny and Suzanne Seriff, 166–79. New York: Harry N. Abrams.

———. 1996 b. "Lavilokan." *African Arts* 29, no. 2 (spring): 22–29.

———. 1995. "Imagine Heaven." In *The Sacred Arts of Haitian Vodou,* 25–55. Los Angeles: Fowler Museum.

Davis, Wade. 1986. *The Serpent and the Rainbow.* New York: Simon and Schuster.

Deren, Maya. 1983. *Divine Horsemen: The Living Gods of Haiti.* London: Thames and Hudson.

Galembo, Phyllis. 1993. *Divine Inspiration: From Benin to Bahia.* Foreword by David Byrne. Albuquerque: University of New Mexico Press.

Greenblatt, Stephen. 1992. *Marvelous Possessions: The Wonder of the New World.* Chicago: University of Chicago Press.

Houlberg, Marilyn. 1996. "Sirens and Snakes: Water Spirits in the Art of Haitian Vodou." *African Arts* 29, no. 2 (spring): 30–35.

———. 1995. "Magique Marasa: The Ritual Cosmos of Twins and Other Sacred Children." In *The Sacred Arts of Haitian Vodou,* ed. Donald Cosentino, 267–85. Los Angeles: Fowler Museum.

Lautman, Victoria. 1989. "Into the Mystic: The New Folk Art." *Metropolitan Home* (June).

Olalquiaga, Celeste. 1992. *Megalopolis: Contemporary Cultural Sensibilities.* Minneapolis: University of Minnesota Press.

Simic, Charles. 1993. *Dime-Store Alchemy: The Art of Joseph Cornell.* Hopewell, N. J.: The Echo Press.

Thompson, Robert F. 1995. "From the Isle Beneath the Sea: Haiti's Africanizing Vodou Art." In *The Sacred Arts of Haitian Vodou,* ed. Donald Cosentino, 91–119. Los Angeles: Fowler Museum.

———. 1983. *Flash of the Spirit: African and Afro-American Art and Philosophy.* New York: Random House.

Walcott, Derek. 1992. *The Antilles: Fragments of Epic Memory.* New York: Farrar, Straus and Giroux.

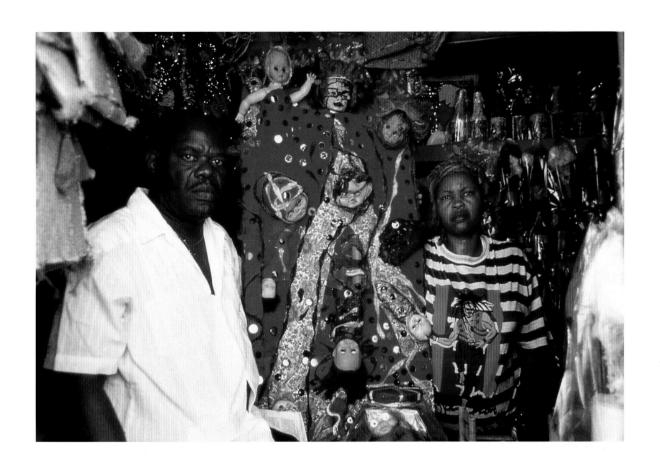

45

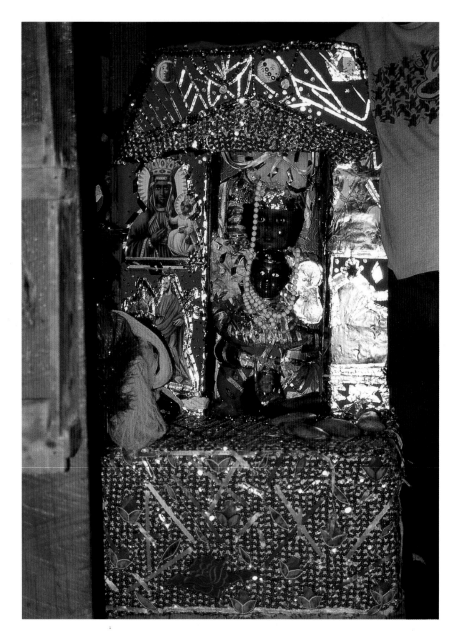

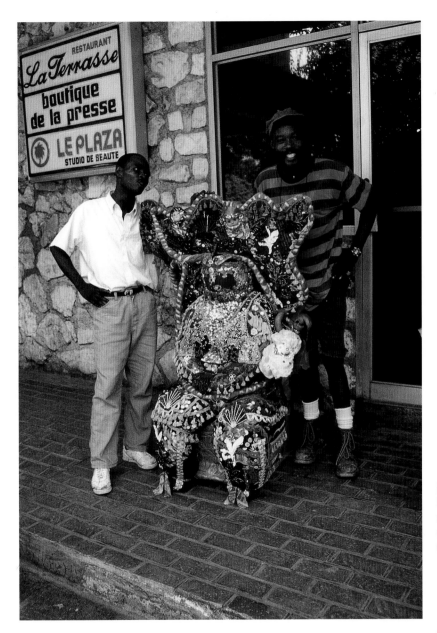

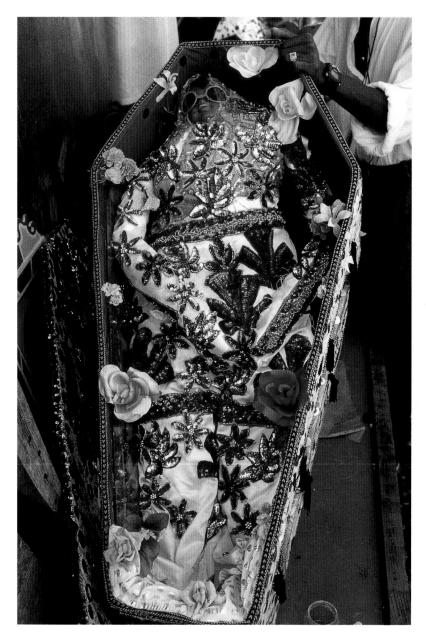

PLATE 4
The florid coffin (*sekey madule*) Barra has created for the queen of Bizango.

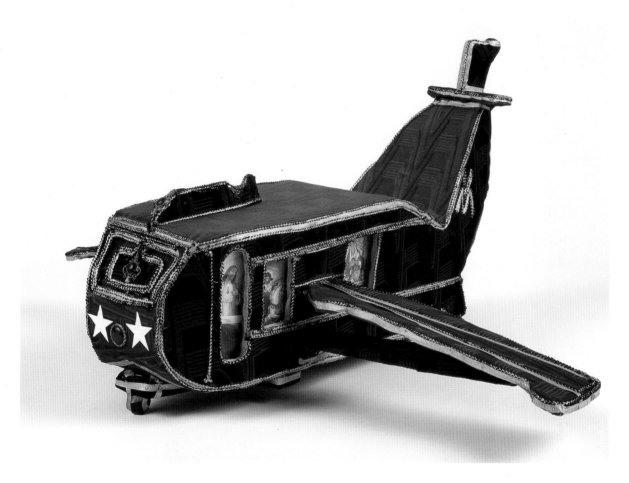

PLATE 5
St. Jacques's mystic jet.

PLATE 6
A fiery St. Jacques leaping
to life on a carousel
horse.

PLATE 7
"When Dantò mounts
her horse, she may take
Manbo Zila and dance her
around Petwo fashion."
Georges René
holding Manbo Zila.

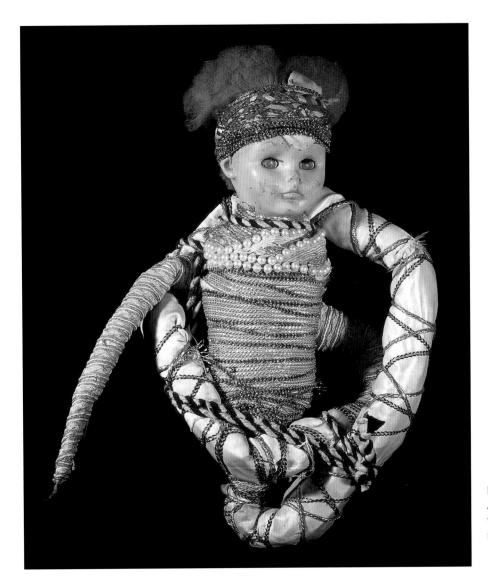

P L A T E 8
A sinuous coil falls from
the rubber head of a
snake deity.

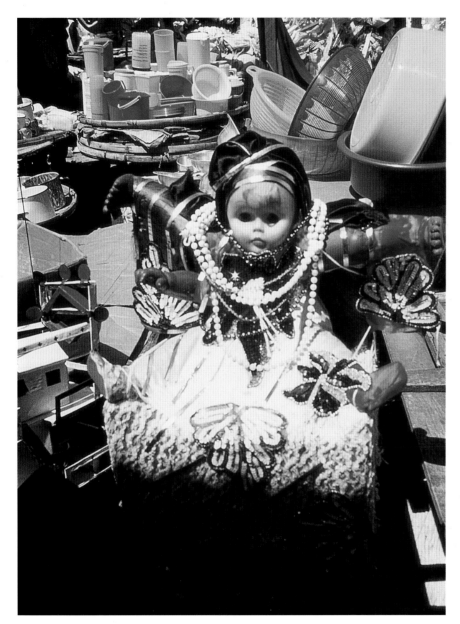

PLATE 9
Ti Jean Dantò dressed up
and tied down for action.

53

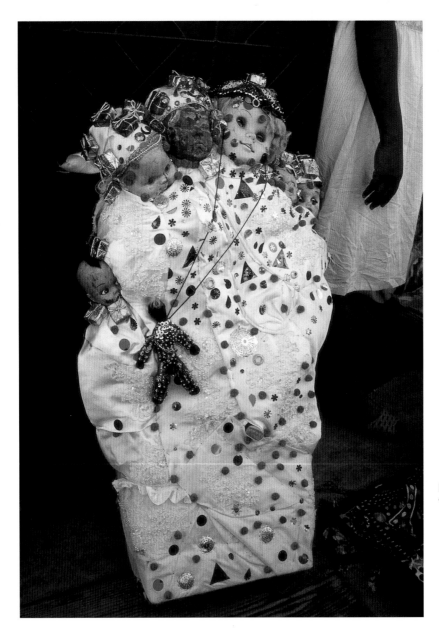

PLATE 10
"The Escort of Ezili."

54

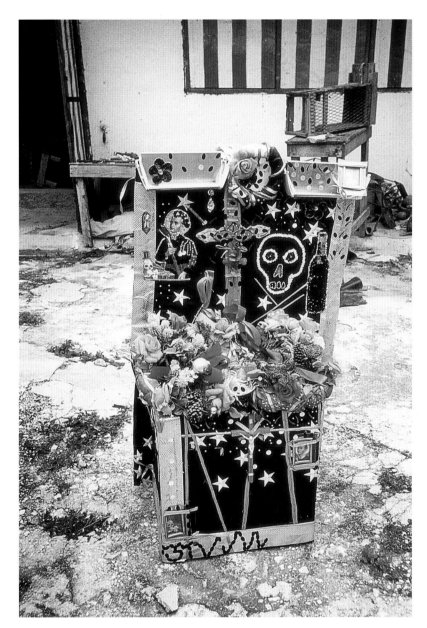

PLATE 11
Barra's altar for Gede.

55

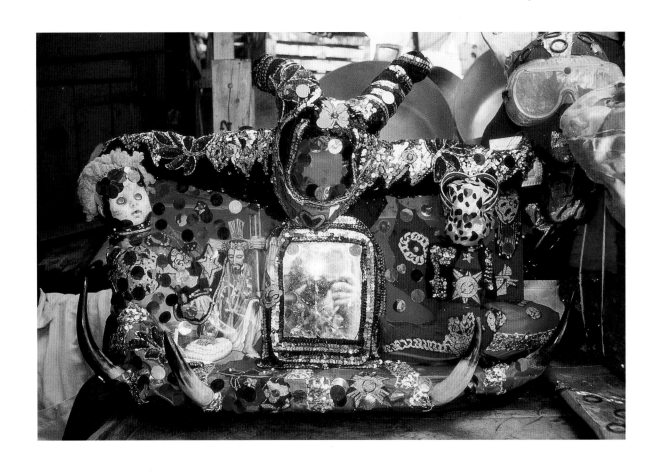

PLATE 12
Bosou altar with mirror,
Iron Market.

56

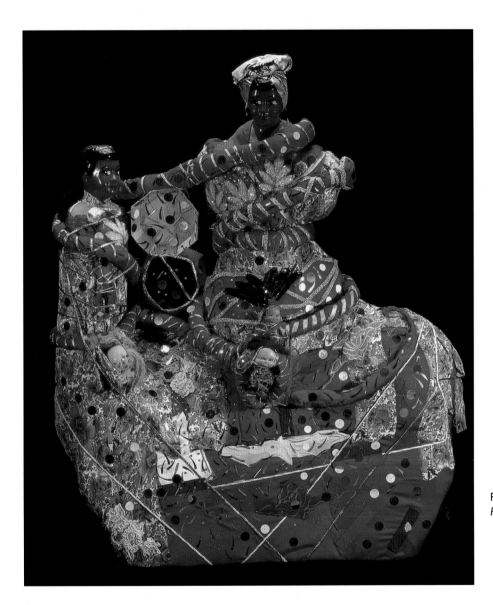

57

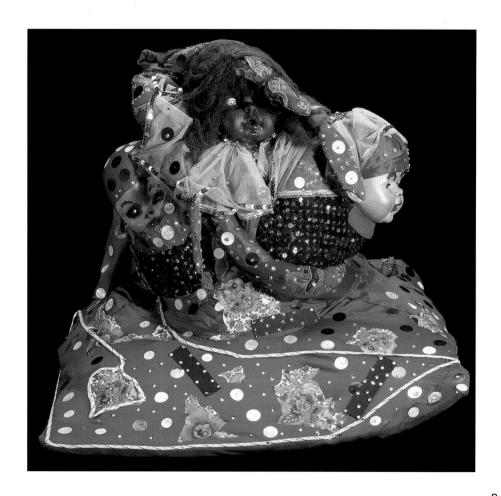

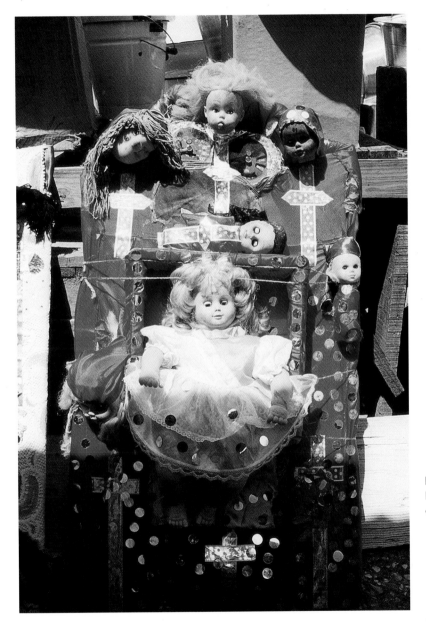

PLATE 15
Mojo board, "En Danger
de Mort."

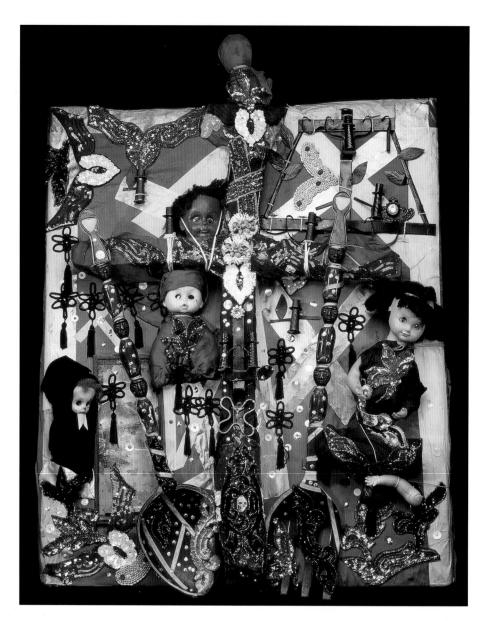

PLATE 16
Mojo board, "Cross with
Spoon and Fork."

60

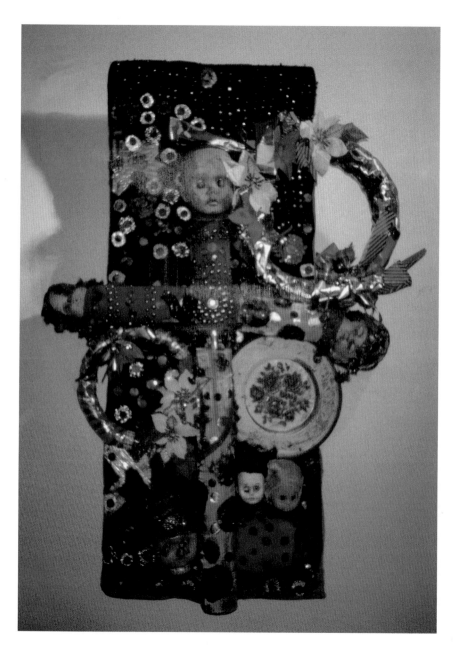

PLATE 17
Mojo board with
Christmas wreaths.

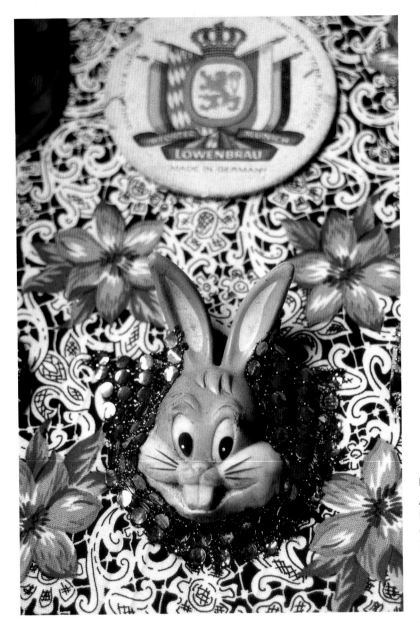

PLATE 18

A plastic head of Bugs
Bunny grins under a
coaster advertising
Löwenbräu beer.

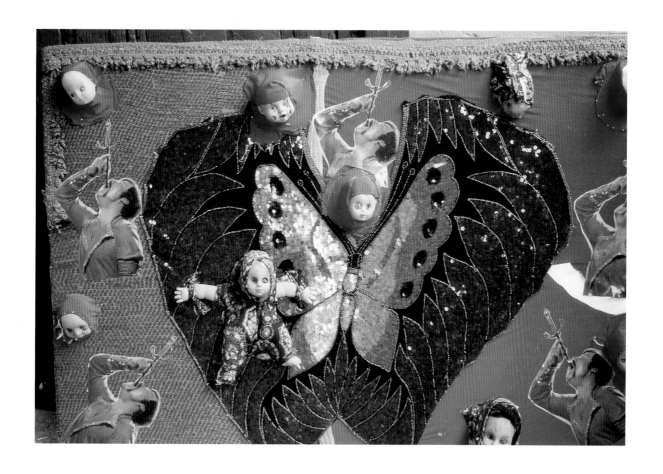

PLATE 19
Multiple cutout images
of a moustached mystic
Petwo sword swallower
embroider a fabulous se-
quined butterfly mojo
board.

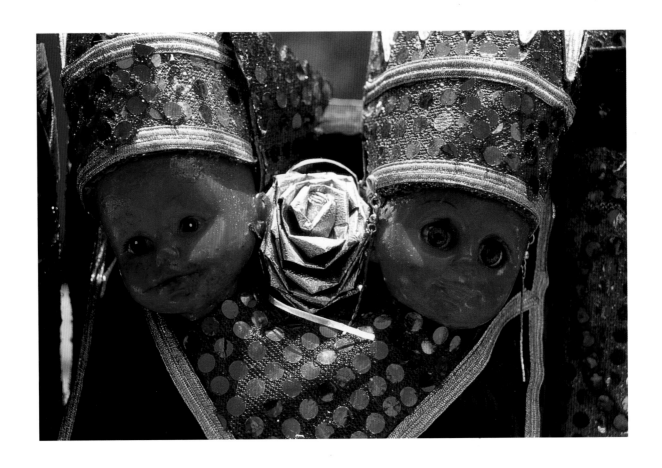

PLATE 20
Red Indian heads are sus-
pended from the top of a
cruciform sculpture.

64

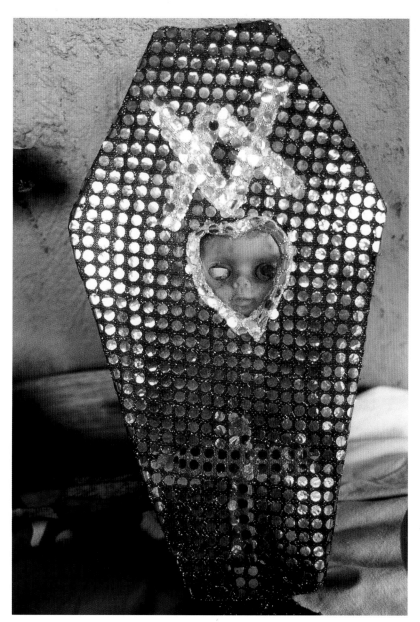

P L A T E 2 1
Little coffin with doll's
head pressed against
peekaboo window.

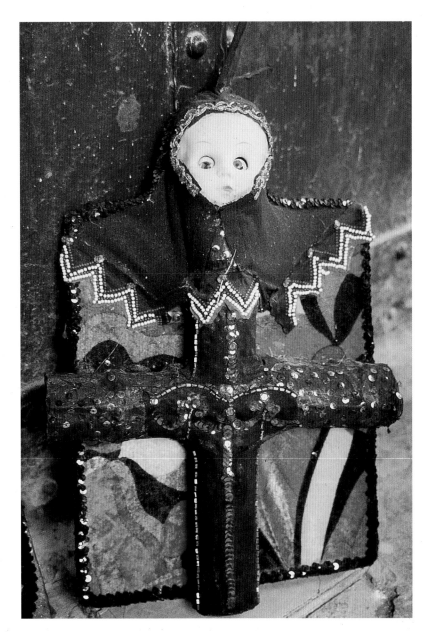

PLATE 22
Anthropomorphic
crosses seem to grow
like dark dahlias on
Barra's verandah.

66

P L A T E 2 3
Because his customers crave strangeness, Barra sometimes uses dolls' heads for shock value.

67

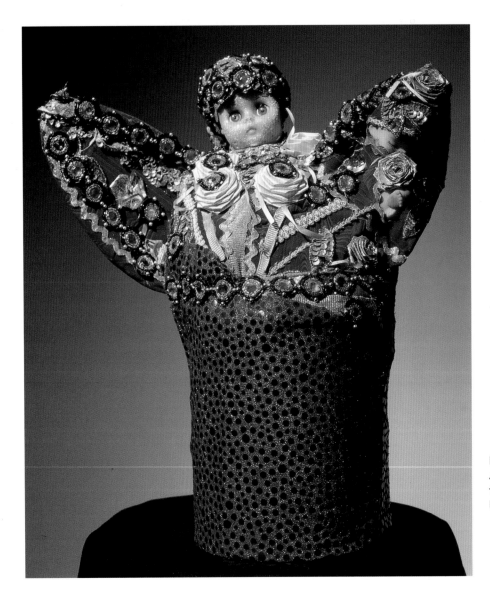

PLATE 24
A blue-eyed doll rises
from a blue-sequined
bottle on butterfly wings.

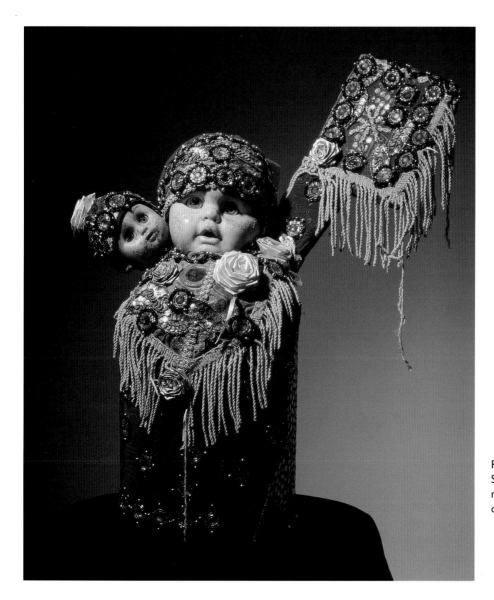

PLATE 25
Sister dolls holding a
miniature Vodou flag rise
out of a wine-red bottle.

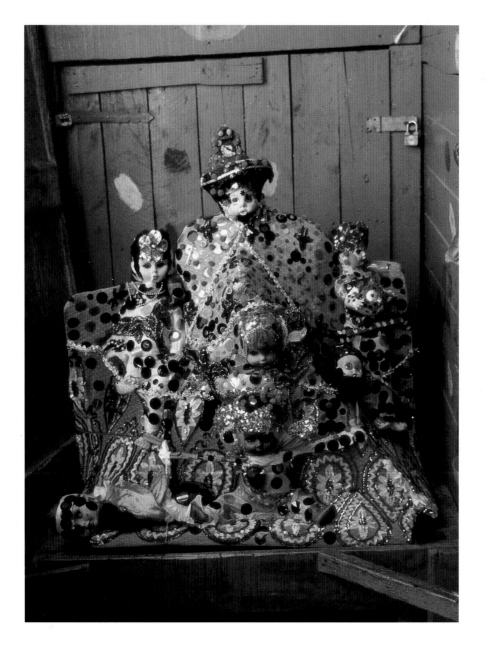

P L A T E 2 6
Barra acknowledges that
the Iwa are glamourous
as well as powerful, with
spangled dolls emerging
from his mojo board like
models from a Versace
Runway.

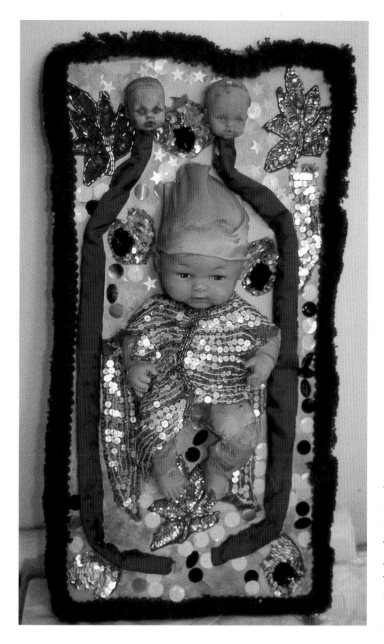

P L A T E 2 7
Barra and Cassaise man-
ifest the marasa (Sacred
Twins) within the out-
lines of a bottle, recall-
ing those which hang
from spirit trees in
African American yards
from Mississippi to
Kongo.

71

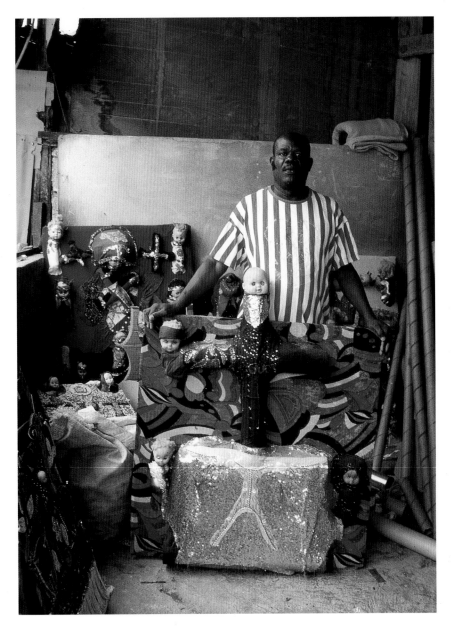

PLATE 28
With X-ray precision, Pierrot Barra is able to discern the Real Presence of the Iwa amidst all the detritus which surrounds him on the verandah of this mother's house near the Iron Market.